Concentric Circles

Monte Packham

Concentric Circles

A Chronicle of Steidl Publishers

with contributions by

Lewis Baltz, François-Marie Banier, Tacita Dean,
William Eggleston, Günter Grass,
Amanda Harlech, Roni Horn, Karl Lagerfeld, Ed Ruscha,
Fazal Sheikh and Joel Sternfeld

Steidl

To Virginia Spate

Introduction
11

Daily Circles
19

August 2008 **20** | September 2008 **22** | Roni Horn **32**

Ed Ruscha **32** | Tacita Dean **33** | October 2008 **35** | Amanda Harlech **51**

Karl Lagerfeld **52** | November 2008 **54** | Lewis Baltz **64**

François-Marie Banier **66** | Günter Grass **68** | December 2008 **69**

William Eggleston **79** | Fazal Sheikh **79** | January 2009 **82**

Joel Sternfeld **92** | Roni Horn **93**

Artistic Circles
95

Jim Dine and Diana Michener **96** | Robert Polidori **102**

Joakim Eskildsen **110** | Juergen Teller **117** | Robert Frank and June Leaf **122**

Klaus Staeck **129** | David Bailey **138** | Dayanita Singh **143**

Conclusion
149

Coda
153

Biographies
157

Introduction

12 September 2009

3:24 pm

A gravel path, lined by tall lime trees, encloses Göttingen's town centre in a broken, sprawling circle. The path sits atop the fourteenth-century wall that once protected the town and was partially dismantled in the nineteenth century. Göttingen has since expanded beyond the wall, whose remains recall its mediaeval past.

This Saturday afternoon, a group of students from Georg-August University walks south along Weender Strasse, headed for the town centre. Some have ponytails and wear backpacks, others push second-hand bicycles. Weender Strasse soon cuts through the wall, and two of the students turn left onto the curving, shaded path that rises from street level. The others continue straight ahead.

On the left of the street are a bakery, a hairdressing salon, an internet café, and a kebab shop where a glistening cylinder of turkey meat turns slowly on a vertical rotisserie. On the right of the street are a shoe repair shop, a tanning studio with plastic orchids in its window, and a McDonalds with a neon sign of the Golden Arches on its façade. Above the sign and at night bathed in its light, is a white marble plaque bearing the words 'Friedrich Ludewig Bouterweck, philosopher, 1815–1828'. Similar plaques, each marking the place of residence of one of Göttingen's notable past citizens, are scattered throughout the town.

A block further south, Weender Strasse transforms from an asphalt road into a pedestrian zone of grey paving stones: the town centre has begun. At Weender Strasse 70 is the tobacconist E. Nehrkorn, where open boxes of cigars line the windows. Outside the tobacconist a mime artist poses motionless, waiting for passers-by to drop coins into a bowl at his feet. A marble plaque with the words 'Samuel Taylor Coleridge, English poet, 1799' hangs above the shoe shop Roland at Weender Strasse 64. The bookshop Jokers occupies the building next door, an ornate half-timbered house from 1549. Elaborate carvings including angels blowing trumpets, a king, and a peasant poking his tongue out cover the façade. Gold leaf on some of the carvings reflects the afternoon sunlight. The windows of the patisserie Cron & Lanz at Weender Strasse 25 boast delicacies including *Baumkuchen,* cakes composed of thin rings of batter covered in dark chocolate. Here are also little raspberry tarts, and marzipan frogs, pigs and ladybirds. Above

Cron & Lanz hangs a marble plaque with the words 'Alexander von Humboldt, naturalist, 1789–1790'.

Weender Strasse soon opens out onto Kornmarkt, Göttingen's market square. Here stands the Old Town Hall of stern grey and red bricks where a tourist shop sells key rings, playing cards, T-shirts and a Göttingen version of Monopoly. Opposite the town hall sits the Gänseliesel fountain with its bronze statue of a young market girl holding three geese. Streams spill from the geese's beaks into the clear water below.

Where Weender Strasse ends, Kurze Strasse begins, home of St Michaelis's church. A black clock face with gold hands and numbers adorns its bell tower. Turning right past the church into Turmstrasse, one passes a thirteenth-century stone tower, once a fortification, now a ruin. A few steps further, Turmstrasse meets Düstere Strasse, 'gloomy street'.

Twenty-six rings of cobblestones mark the intersection between the two streets. To the left, a screen of lime trees growing on part of the wall surrounding Göttingen's centre is visible. Turning right into Düstere Strasse, one soon reaches a nondescript red-brick building from 1986. Bicycles lean against the metal security gates at its base. Behind the gates is a door of dark wood with a letterbox flap. On the flap is printed: 'Steidl Publishers. No junk mail'.

4:11 pm

Opening the door, one sees a staircase of terracotta tiles leading upwards. To the right, a white door opens onto the room where the printing films and plates for each Steidl book are made. Here are the sound of an exhaust fan and the smell of developing fluid. Michael Cerny, pre-press, is currently making plates for a reprint of Günter Grass's *Fundsachen für Nichtleser.* He places the finished aluminium plates on top of one another, laying a protective sheet of tissue paper beneath each one.

A door to the left of the terracotta staircase, marked 'Pressroom – no entry', leads to the long hall that houses Steidl's two printing presses, a MAN Roland 200 and a MAN Roland 700. The smell of ink and cleaning fluid permeates the air. Directly ahead lies the Roland 200, 2.2 metres wide and 2.5 metres long, and in places smeared with ink. The press is resting this afternoon and sits in half-darkness.

To the right of the Roland 200, past pallets of paper, an industrial guillotine and shelves laden with tubs of ink, is the Roland 700, manned this afternoon by Arne Halm and Carsten Goltzsch. The press is 3.65 metres wide and 13 metres long, and has six printing towers compared to the Roland 200's one. A metal walkway runs the length of the machine, allowing the printers access to the towers to change plates and administer ink. The sound of the Roland 700 operating at full speed is two-fold. First there is an industrial din of running motors. On top of this is a rhythmic beating, as the sheets of paper move from one end of the machine through the printing towers, each containing a different coloured ink or varnish, to the other end, where they shoot onto a wooden pallet.

A steel door opposite the Roland 200 opens onto a poorly ventilated stairwell, where the sounds of the printing press are muffled. A pale terrazzo staircase leads upwards, first to the floor where the scanning and photographing of artworks, digital colour correction, and proofing take place. Here are wooden transport crates, photographic equipment, large computer screens, drum scanners, and white cotton gloves for handling artworks.

The staircase leads next to the typography level where the design and typesetting of books occur. A door opens to reveal a long desk covered by computers, grey cardboard trays containing assorted papers, scattered stationery, telephones, books and maquettes. To the left is a row of windows facing Düstere Strasse, and past it a cluster of offices for sales and marketing, rights and licences, book exports, and accounts and bookkeeping. Gerhard Steidl's office is also on this level.

The entrance to his office is a wide doorframe from which the door has been removed. Above the lintel is a small gold plaque with the words 'Callers will only be allowed access if they have an appointment or can produce identification which *will* be checked.' Through the doorframe this afternoon one sees a white lab coat hanging on a chair facing a small desk supporting a Brother AX-410 typewriter with dirty keys. Above the typewriter hangs an A5 sheet of red paper with the black text: *'Tous est politique'*. To the left is a cluttered desk before which stands a black stool. In the centre of the room is an island of filing cabinets bearing tilting stacks of folded but unbound books.

The staircase finally leads to a grey granite kitchen on the third floor. To the right of the kitchen is a dining room with a long pale wooden table and ten chairs.

To the left of the kitchen is a library with an alphabetised wall of books facing Düstere Strasse. Past the library are the editorial and publicity departments, lined with novels, dictionaries and piles of A4 print-outs awaiting correction. Next to an editorial office is a balcony, which returns one to the fresh air. From here one looks down onto a small garden with clumps of ferns, a wall draped with ivy, and an apple tree bearing red fruit. To the left of the garden is the pressroom. As the wind moves the branches of the apple tree, the rhythmic beating of the printing press rises skyward.

This book chronicles some of the circles that constitute Steidl Publishers. These include photographers, artists, authors, employees, books, anecdotes, experiences and impressions – the many facets that characterise the printing and publishing house. Here are circles of progress and failure, of decision and uncertainty, of the mundane and the seductive, of routine and impulse, of action and reflection. *Concentric Circles* is not a comprehensive history of Steidl: it does not describe all those who have visited Göttingen to make books, nor does it include every employee. Many circles go unmentioned. *Concentric Circles* is rather a selective portrait of Steidl made within a limited time frame. The first part of the book is a log written within the walls of Steidl at Düstere Strasse 4, recording events there as they unfolded between 26 August 2008 and 27 January 2009. A handful of texts from photographers, artists and authors about their experiences at Steidl is placed throughout the log. The second part of the book consists of interviews with ten photographers and artists whose books have shaped Steidl's ongoing history.
A chronicle of Steidl Publishers cannot help being, to an extent, a book about Gerhard Steidl. (In the pages that follow I use '*Steidl*' to refer to the publishing house and 'Steidl' to the man.) Put simply, there would be no *Steidl* without Steidl, who began printing alone with a silk-screen frame in 1966 and continues to shape the books that bear his name. That said, *Steidl* is no longer a one-man show: at the time of writing the company has forty-five employees.
When contemplating the manifold circles that shape life at Düstere Strasse 4, I picture them as concentric – as circles of different sizes radiating from a shared centre. These are circles in flux: new ones perpetually come into being as old

ones fade around a shifting centre. Some are sleek and geometric like the clock face of St Michaelis's church. Others are rough and composite like rings of cobblestones. Others still are grand and fragmentary like the remains of the wall that surround Göttingen's town centre. Despite their diversity, each circle is one among many within a greater, mobile whole.

Daily Circles

August 2008

26 August 2008

1:49 pm

Gerhard Steidl is sprawled on the floor of the typography level at Düstere Strasse 4, his legs protruding from his white lab coat. Today he is designing print advertisements for Günter Grass's recently published novel *Die Box* ('The Box'). Copies of the *Süddeutsche Zeitung* and the *Frankfurter Allgemeine Zeitung*, the newspapers in which the ads will appear, lie open on the parquet floor before him. Each ad will include the pen drawing by Grass of an Agfa box camera that adorns the dust jacket of *Die Box*.

Steidl studies colour print-outs of the future ads that have been placed over the newspapers to simulate how they will appear in the newspapers, surrounded by the bustle of text and image. Jan Strümpel, editor, and Sarah Winter, designer, stand on either side of Steidl, awaiting his criticism. Steidl verbalises his opinions, immediately revises them – 'I'm talking crap' – and marks his corrections on the print-outs with a blue permanent marker.

27 August 2008

2:44 pm

Herr Oschmann, the bookbinder opposite *Steidl* at Düstere Strasse 26, has just delivered a stack of pale grey, handcrafted boxes. Each box will house the mix of materials that relates to a single book project: perhaps drawings, handwritten letters, faxes, photos, brass embossing tools, scraps of linen.

4:48 pm

Steidl's typewriter makes *tik tak* sounds as he attacks its keys.

28 August 2008

6:36 pm

Bernard Fischer, production manager, sits at his computer with Susan Meiselas, placing images in the layout of her book *In History*. 'Do you see what I'm seeing?' asks Meiselas, as her hand shoots towards the screen. Behind her, the evening sun filters through the windows facing Düstere Strasse.

6:43 pm
The phone on Sarah's desk rings: it is Steidl asking her and Katharina Staal, designer, to come up to the library; Katharina sighs. 'Now that's what I call a couple of fit young women!' exclaims Hilda Hebestreit, housekeeping, as they head upstairs. 'Enjoy your life' is spelt out on Hilda's T-shirt in red and silver sequins.

28 August 2008

1:12 pm
Steidl and Sarah are designing the dust jackets of the German novels to be published in Spring-Summer 2009. As they crop photos and tweak typography on the computer screen, there is a sudden thud behind them as Heiko Schaper, the builder coordinating the renovation of the new *Steidl* guest apartments at Nikolaistrasse 22, drops a thick piece of wood onto the floor. This is a flooring sample from the apartments, and has been stained with three different finishes: greenish brown, red-brown and a mix between the two. Steidl swivels on his stool to inspect the samples, his head tilted to the right, his left thumb and index finger forming a ring through which he squints. He decides on the red-brown, and Heiko disappears with the wood into the stairwell.

4:14 pm
Steidl, Sarah, and Judith Lange, pre-press, are seated at Sarah's computer screen. The phone rings and Sarah moves to answer it, expecting an urgent call: 'Don't pick up!' snaps Steidl. Sarah hesitates, by which time the phone has stopped ringing.

4:57 pm
Steidl asks me to call Robert Frank to check if he received Steidl's fax with the contact details of Frank's favourite hotel in Zurich: 'If Robert answers, just ask him; if June answers, just ask her.'

September 2008

8 September 2008

9:53 am

Steidl has laid a photocopy of an article from the *Frankfurter Allgemeine Zeitung* about Karl Lagerfeld's recent birthday on my desk, together with a little piece of chocolate. Sarah finds a similar photocopy and piece of chocolate on her desk. Perplexed, she asks from where they came. 'From Steidl,' replies Katharina who has also received the gifts. Katharina shows the sceptical Sarah Steidl's handwriting on the photocopy – 'for Sarah' – and I hold up my chocolate as proof that he is indeed the gift-giver. Flattered, she smiles.
Steidl's bunch of keys, worn as always at the waist beneath his white lab coat, jangles in the stairwell behind us: he enters.
Sarah turns on her chair to face him: *'Danke!'*
Steidl grumbles a response, complaining that half of the company has taken time off in September, the busiest month of the year.

15 September 2008

11:27 am
Steidl: 'If the typography isn't any good, then there's no hope.'

16 September 2008

8:52 am
This morning the cusp between summer and autumn is perceptible. Claudia Glenewinkel, press officer and editor, arrives in the office in her winter coat for the first time this year.

9:48 am
Diana Michener enters the typography level, with dark-tinted glasses and her hair held behind her head with a clip: 'Good morning!' Robert Polidori follows her: 'Hallo! Hallo!' Both greet Bernard who has been away ill.

10:03 am
Steidl is seated with Jim Dine, Michener, and Jonas Wettre, designer. A CD has been sent by *Steidl* to the Getty Museum containing a musical recording from Dine's *HOT DREAM (52 books)* – a collection of fifty-two books of Dine's paint-

ings, drawings, collages and photos, and ten CDs of his poetry recordings. Steidl, huffy, complains that the production costs for *HOT DREAM* were over 300,000 euros and that as a result nothing should be sent to museums free of charge: 'We shall not make gifts to those guys; they do not make gifts to us.'

10:36 am
Steidl rummages in his office for a sketch by Dine that he has misplaced.

10:56 am
Polidori, who has been waiting in the library, pokes his head into Steidl's office. 'I have not forgotten you,' says Steidl, 'I am coming.'

17 September 2008

11:27 am
Eric Pfrunder calls Steidl to explain that Lagerfeld will take the photo today to be printed on the invitation and presskit for the Chanel Prêt-à-Porter Spring-Summer 2009 fashion show on 3 October. Pfrunder, *Directeur de l'image mode* at Chanel, and Lagerfeld's *'Vorarbeiter'* who in 1987 first suggested he start taking photos, explains that Lagerfeld would like the invitation to have a 'modern feel' and so should be printed not on paper, but on plastic.
Frank Hertel, one of *Steidl*'s drivers, will travel from Göttingen to Paris this morning by car – seven hours there and six and a half back – to collect a CD containing Lagerfeld's photo. (Frank will return to Göttingen tomorrow morning, when he will drive again to Paris with new deliveries.)
There is a rush to assemble the items Frank must take with him this morning: two handmade white linen boxes with the Chanel logo screen-printed in glossy black on the lid, and three handmade white paper shopping bags (advance packaging samples for gifts to be given to the guests at the opening of the Chanel Mobile Art Container in New York's Central Park on 21 October).

11:34 am
Steidl is looking for samples of plastics that could be used for the invitation. He pulls open a wide metal drawer in his office containing hundreds of CDs in overlapping plastic cases. These contain photos by Lagerfeld from past fashion advertising campaigns; their titles, scrawled in black, include 'Maison Michel', 'Chanel Lunettes Optiques et Solaires' and 'Fendi PAP FW08/09'. Steidl searches

among the CDs and assorted flotsam in the drawer – including brass dies, print-outs, and handwritten faxes – before emerging triumphantly with a shallow cardboard box containing plastic samples in varied colours.

11:40 am
Frank departs for Paris.

18 September 2008

1:40 pm
Roni Horn has arrived to complete her book *Roni Horn aka Roni Horn*, to be published for her retrospective exhibition of the same name at Tate Modern from 25 February to 25 May 2009.

2:02 pm
Steidl greets Roni with a kiss on the cheek. She asks him how he would like to begin working: 'Let's have lunch first,' he replies.

3:05 pm
Steidl, Roni, Bernard and Katja Töpfer, pre-press, discuss how to proceed with *Roni Horn aka Roni Horn*. Roni will continue designing the book on her laptop, Bernard will prepare her InDesign documents for printing once the design is complete, while Katja will work parallel on the image corrections with Roni. 'I like InDesign, but they always give me Quark,' says Steidl.

3:33 pm
An amused, almost mischievous Steidl tapes a photocopy on the wall above Sarah's head. It depicts an artwork by Joseph Beuys in which the words *'Nur noch 1.650 Tage bis zum Ende des Kapitalismus'* ('Only 1,650 days until the end of Capitalism') are scrawled on a blackboard in white chalk. A whimsical drawing of a whale occupies the bottom left corner of the blackboard.

3:59 pm
Frank has returned from Paris with Lagerfeld's photo for the Chanel invitation and presskit. The photo depicts a fastidiously detailed model of Chanel's head-quarters at 31 Rue Cambon, a five-storey eighteenth-century building in Paris's first arrondissement. The model of painted wood and cardboard conveys both the building's appearance and character: the elegant but worn off-white stucco façade, the faux cast-iron balconies before the tall windows, the chimney stacks,

the white awnings adorned with black 'double C' logos fluttering in the wind. Wooden scaffolding scales each side of the building and a makeshift corrugated iron fence frames it at street level, giving the model the look of a construction site.

19 September 2008

9:12 am

Steidl has made a test-print of the Chanel invitation, a portrait-format, folding A5-size card, and received feedback on it from Paris. The Chanel logo (underneath the façade of 31 Rue Cambon on the front of the invitation) must be darkened to match the grey colour of the corrugated fence in the model.
The text, printed in a similar grey on the inside of the invitation, reads:

CHANEL
Prêt-à-Porter Printemps-Été 2009
Vendredi 3 Octobre 2008
à 10h30
Grand Palais
Avenue du Général Eisenhower
Paris 8ᵉᵐᵉ
Service de Presse – Tél.: 01 42 86 28 00
Cette carte et une pièce d'identité seront demandées à l'entrée.

10:58 am
Roni greets Steidl who replies, 'Half an hour or so.'

11:01 am
Steidl reminds Jennie Ross, who is in Göttingen to colour-correct Polidori's photos of the palace of Versailles in his three-volume *Parcours Muséologique Revisité*, always to lock the doors behind her when working late in the office.

11:12 am
Eric calls Steidl: Karl would still like plastic for the invitation, but this is impractical for the presskit as the plastic cannot be folded.

12:38 pm
Roni to Bernard: 'Oh, we have print-outs babe!'

12:47 pm

Jerry Berndt has arrived to prepare his book *Insight* for printing. Steidl welcomes him with the words, 'I am extremely busy today but I will find some time. I am there in half an hour.'

1:25 pm

Steidl asks Berndt to choose a photo for the front cover of *Insight*. Steidl likes the idea of a photo-story on the back cover, and asks Berndt where he lives: 'Paris,' comes the reply. 'I married a French woman who didn't want to live in the United States. I don't complain, I was happy to get out.'

2:32 pm

Steidl and Berndt discuss the colour of the endpapers for *Insight*. 'Could be a red,' suggests Steidl. 'A very dark red,' agrees Berndt.

4:42 pm

Steidl flips through a dense stack of print-outs of a PowerPoint presentation: 'If there's one thing I hate in life, it's PowerPoint.'

4:50 pm

Steidl asks Eric, 'Do you have any news from Karl?'

22 September 2008

11:32 am

Steidl apologises to Sophie Lorthois, international events manager at Chanel, that the invitations (ultimately printed not on plastic but on paper to simplify production) will be delivered late. There was a problem obtaining the paper: 'These things happen.' He says the badges, made of polyurethane and worn around the necks of the crew at the fashion show, are in production and will be delivered to Paris on 26 September.

12:23 pm

Cordula Lebeck has arrived to work on her husband Robert Lebeck's book *Fotoreporter*, to be published for his exhibition 'Fotografien 1955–2005', from 28 November 2008 to 23 March 2009 at the Martin-Gropius-Bau in Berlin.

12:57 pm

Matthias Wegener, sales management, has elegant and legible handwriting. For this reason Steidl has asked him to number by hand one thousand black cards

which have been printed for the Dom Pérignon Œnothèque 1993 *Bol Sein.* Matthias is to write the numbers, from 1/1000 to 1000/1000, in a fine silver pen. He lays the cards out on the library table like a dark blanket and begins his task in earnest. The Bol Sein (literally 'breast bowl') is a porcelain drinking cup designed by Lagerfeld and modelled on Claudia Schiffer's breast. One thousand cups are to be sold, each with a bottle of Œnothèque 1993 champagne and one of the black cards as a certificate of authenticity. Lagerfeld's cup is a reinterpretation of the original eighteenth-century Bol Sein, a bowl of Sèvres porcelain supposedly modelled on the breast of Marie Antoinette. Four of these cups were manufactured and once adorned the Laiterie de la Reine at Rambouillet Chateau, a pleasure dairy given to Marie Antoinette by her husband Louis XVI in 1786, to entice her to visit the chateau which she otherwise found gloomy. (She unfortunately lost her head before she could enjoy her dairy.)

Matthias patiently inscribes each card with his cursive script. He gathers the numbered cards in bundles, secures the bundles with rubber bands, and places them in a cardboard box, ready for delivery to Paris.

3:26 pm

Polidori has left Göttingen for Versailles to take more photos.

23 September 2008

8:54 am

The chill of autumn has set in: the sky is pale grey and rain lacquers Göttingen's red rooftops. Restlessly, Steidl shuffles papers on Katharina's desk.

10:17 am

Nicolas Pages has arrived to discuss *YUL: A Photographic Journey,* a book of Yul Brynner's photos to be released by Edition 7L, Lagerfeld's publishing imprint with Steidl. The book will contain colour and black-and-white photos taken by Brynner on the sets of his films, as well as portraits of family and friends including Charlie Chaplin, Ingrid Bergman and Elizabeth Taylor. Pages, now based in Los Angeles, worked as Nan Goldin's studio manager for a decade.

10:19 am

Steidl, Roni and Bernard discuss progress on *Roni Horn aka Roni Horn.* Steidl asks Roni to ensure that she prepares the different elements of her book – its

inner pages, endpapers and cover – as separate InDesign documents. 'As long as Bernard understands it, I'm happy,' she says.

10:22 am

Judith emails PDFs of the 'Open Doors' cards for the PAP SS09 collection to Chanel for printing approval. These cards are invitations for members of the press to visit select boutiques on an open day and inspect the new collection. The cards feature Lagerfeld's photo of 31 Rue Cambon on one side, and text on the other. Five versions, each in a different language, will be printed for events in Paris, London, Milan, Madrid and Munich.

4:51 pm

Chanel emails corrections for the Open Doors cards: 'OK for UK, France and Italy. For Germany, OK for the invitation card but for the reply card: on "Seite 1" we need a space between "Sommer" and "2009"; and on "Seite 2", "Chanel GmbH" is too small compared to the address.'

24 September 2008

1:02 pm

Steidl and Sarah discuss the design of a book for Graciela Iturbide, winner of the 2008 Hasselblad Foundation International Award in Photography. The books honouring the winners of the annual award are conceived to form a series: they share the same format and font, as well as a basic design structure that is modified from book to book. Steidl removes a copy of the book for last year's winner, Nan Goldin, from the shelf above Sarah's head and says Iturbide's should follow its structure: *'Alles folgt diesem Salat.'*

25 September 2008

6:32 pm

I have just booked Steidl's flight to Paris for the Chanel PAP SS09 presskit shoot, taking place tomorrow at 5:00 pm. At the shoot Lagerfeld will take photos of models in various garments from the new collection. Steidl will print the photos on loose cardboard sheets that will be inserted into the presskit folders. The complete presskits will be gifts for the guests at the fashion show.

26 September 2008

9:58 am

Steidl has left for Paris: the white lab coat hanging limply on the dark red Jean Prouvé Standard Chair at his typewriter marks his absence.

29 September 2008

9:56 am

Polidori has returned from Versailles with new photos. He has accidentally deleted three images from his computer, which he accepts is bad luck: 'I don't have time to go back, I need to finish the book.' He is unsure whether to wait for Steidl outside his office or upstairs in the library. Steidl asks him to go to the library: 'I have to give you some explanations, I am there in one minute.'

10:21 am

Gunilla Knape of the Hasselblad Foundation has arrived to complete Iturbide's book. She begins making text corrections with Sarah.

10:26 am

Bernard wonders if a CD of new scans for *The Ferus Gallery: A Place to Begin* has arrived. Steidl nods his head and points to a battered FedEx box lying next to the photocopier.

10:59 am

Polidori is twitchy. 'I've changed a few things, I've brought new pictures,' he says to Jennie as she colour-corrects one of his photos on her computer screen, her finger tapping her mouse as if she were sending Morse code. 'I gotta do twenny a day now if you wanna finish on time, so I don't wanna hear about any more!' she exclaims with a laugh. They discuss how many photos are still to be corrected and proofed. Polidori is at ease by the end of the conversation: 'I'm basically in a good mood now.'

12:59 pm

I ask Polidori if he has now finished taking photos at Versailles. *'Oui ...* for *this* book ... *oui,'* he replies. I ask how it has been to interact with the bureaucracy at Versailles: he is well-practised after twenty-five years, he says. The first director of Versailles with whom he had contact was fond of Polidori, and would give him the keys to the palace whenever he came to take photos. Some employees

working under this director disliked Polidori however, and were promoted when the director died.

Today Polidori enjoys strong relationships with the many young people working at the palace: he plans to invite one to Göttingen to check the titles of the artworks at Versailles reproduced in the book.

3:36 pm

The photos for the Chanel presskit are being printed on the Roland 700. The set in which the models Anna Jagodzinska and Baptiste Giabiconi pose depicts a grey asphalt road and corrugated iron fence, recalling the streetscape in Lagerfeld's photo of 31 Rue Cambon.

30 September 2008

9:02 am

Polidori sails into the typography level, hair slicked back, a large takeaway coffee cup in hand, and heads to the library: 'Good morning!'

9:06 am

Jan grins at a teddy bear in Lagerfeld's likeness staring at him sceptically from my desk. Crafted by Steiff, the bear mirrors Lagerfeld's appearance with a black suit, jewel-encrusted belt and aviator sunglasses. Lagerfeld gave the bear to Steidl at the Chanel shoot, saying with a smile that he couldn't stand looking at his own likeness.

9:32 am

Steidl is coordinating two drivers: Hendrik Anders, known as Henny, will depart shortly to the bookbinder Lachenmaier in Reutlingen to pick up freshly bound books and continue to Stockholm to deliver them to the Moderna Museet. Eberhard Joost, known as Zinky, waits with arms crossed, restless but in good spirits, for his instructions. (Steidl and Zinky met when Steidl was eighteen and Zinky sixteen, at the Centre Club in Göttingen. At the time Steidl was looking for a driver and Zinky volunteered his services, despite not having a driving licence.)

9:54 am

Sarah is ill, though still at work: with a scarf bundled around her neck, she refines the sequence of photos in the Iturbide book with Gunilla.

4:18 pm

Steidl and Robert Walther, export management, argue about the delivery of four thousand copies of *Beuys. Die Revolution sind wir* to the Hamburger Bahnhof musuem in Berlin.

6:03 pm

'Did I ever tell you about my career as a window dresser?' Steidl asks Katharina. 'Not yet,' she replies.

With a sparkle in his eye, Steidl explains how as a teenager he would wander Göttingen's town centre, taking photos of shop window displays. He would develop the photos, and show them to the shop owners as proof that their displays were somehow unsatisfactory – cluttered, spare, poorly arranged, or simply lacking allure. Steidl would then offer to redecorate each display at a cost of forty marks, and if subsequently employed to do so, take a photo of the new display and also sell that to the shop.

Roni Horn

New York, 17 December 2008

OK. A story about Gerhard. About Steidlville before it had such a sweet name. I think it was summertime. Just a few people were working pre-press. The scan man wasn't around. New hardware had just been installed. No one really knew how to use it. I was working on *This is Me, This is You*. The proofs were coming out strange. We tried and tried again. It just wasn't working. I was getting upset – no control – nothing. I got pissed with Gerhard. Told him it all looked like crap. Then he got pissed with me. The two of us were mad dogs. I left. Left that damn Christmas village. I thought: 'Shit, I might never do another book again.' I was so upset. Time went by. I got a fax, a typewritten letter from Göttingen. It said:

I just want to float on a cloud with you,
Above all the nonsense – and make a book.
Gerhard

Ed Ruscha

Los Angeles, 1 September 2009

I have been searching, searching, searching to find a word that fits our good friend Gerhard Steidl and I've finally found it ... *wizard!*
It's the wizard's world and we live in it. He ticks like a fine watch!

Tacita Dean

Berlin, 28 May 2009

I first met Gerhard on my thirty-fifth birthday. It was a Sunday. I wanted to make a book of found photographs called *FLOH,* and to publish it entirely without words: without my name and without even his. I wanted the photographs to have the silence of the flea market, neither appropriated nor described. Another publisher hadn't wanted to take the risk, but Gerhard enjoyed and embraced it. I understood immediately that he was an image man. For a long time into the project he called the book 'the flea'. As I left that day to take the train back to Berlin, he gave me a bottle of champagne, and later, after *FLOH* was published, he asked if he could be my 'house publisher' – one of the most pivotal and important moments in my working life.

I love making books like I love making films and drawings, and photographs and prints. For me, they are all equal parts in the same process, and to make a book is to make a work of art. To be facilitated and hosted in the transformation of an idea into the physical form of a book, however eccentric or impractical or non-commercial it is, is an act of immense generosity. When Gerhard offered me this, he gave me the chance to imagine in the form of a book, and to make it integral to what I do and intrinsic to my work as an artist.

Gerhard is a master technician who oversees every stage of a book's production. He is a publisher who gets dirty and loves the stuff of his manufacture: the ink, the paper, and the cloth. For me, he is an undisputed king in his quixotic world, and true to his word, has printed and published all the books and oddities I have presented him with over the years. He has never disappointed me, and has treated each project with unfailing attention and care, especially when sometimes they were so small, as small even as a picture postcard. It is an unquestionable pleasure to be beloved by him, and I brim full of gratitude for that moment that brought me into his lair.

But this doesn't mean to say that I'm not still terrified of asking him for something, because I am. Nor does it mean that I relish my trips to Göttingen, because I don't very much. They are hard. Gerhard transforms in a white coat.

He is brusque and busy like any matron in a uniform having to tolerate another body on her ward. It is a game of waiting to be seen to and for one's time on the press. And I have learnt, over the years, to be unequivocal in the knowing of my own mind, and to be clear and concise, and not to be profligate with those plastic folders. There is also a particular solitude in making a book with Gerhard in Göttingen: a strange, ascetic ritual played out in the many storeys of the Düstere Strasse complex. But you know that such concentrated isolation is for the purpose of achieving something important, and that in the end, there can be no greater elation than handling your newly printed book, freshly smelling of ink, and still sticky to touch, torn and folded by Gerhard as a parting gift on your way out.

October 2008

1 October 2008

9:44 am

Autumn has settled in: sodden yellow leaves line Göttingen's cobbled streets.

9:57 am

Polidori enters the typography level, his glasses perched on the tip of his nose: 'Sorry to disturb you, but do you have any paper clips?'

10:39 am

Steidl sifts through invoices at his desk, sorting those paid from unpaid, highlighting in lurid yellow.

12:04 pm

Steidl is on the phone to the embossing specialist Imberger in Stuttgart, ordering a die for the cover of Ed Ruscha's *On the Road*. The book, to be produced in a limited edition of three hundred and fifty leather-bound copies designed by Ruscha, will combine the text of Jack Kerouac's 1957 novel with black-and-white photos by Ruscha that illustrate the story. These images include mechanical tools, a half-empty beer glass, a bunch of grapes, and the cracked asphalt of a road photographed from above. Kerouac's text will be printed in letterpress, and Ruscha's photos tipped in by hand. 'Ruscha,' says Steidl to the person on the other end of the line, who has trouble understanding. 'Rusch*a*,' he repeats with increased volume: 'RUSCHA. RUSCHAR. R.U.S.C.H.A.'.

1:01 pm

Steidl is discussing *Cocksucker Blues*, Robert Frank's 1972 film documenting the Rolling Stones' Canadian and North American tour in support of their album *Exile on Main Street*. Steidl wants to include the film in 'Robert Frank: The Complete Film Works', a series of DVDs he is producing. ('The Complete Film Works' was born when a visitor to Frank's New York Bleecker Street house stumbled across the films in neglected, dust-covered canisters piled in a stairwell.) Steidl is seeking permission to release *Cocksucker Blues* to the general public – at present it may only be shown in museums in Frank's presence. The Rolling Stones have not approved the film for public release on the grounds that there is too little front-stage and too much backstage footage shown (images of

drug-taking and group sex also play no small role). Frank has suggested solving the problem by simply adding outtakes of front-stage footage to the film.

2:06 pm
Thin autumn sunlight illuminates the birch trees as they are stirred by the wind, and penetrates the window behind Bernard's desk.

2 October 2008

10:47 am
Jennie asks Polidori how he is: 'Not well, today's hard,' he replies.

1:43 pm
A decadent print will accompany the Dom Pérignon Œnothèque *Bol Sein,* in addition to the black certificates of authentication. The print is being produced on the Roland 200. The image is one of Lagerfeld's photos from the Œnothèque 1993 advertising campaign and depicts an eighteenth-century love affair: Claudia Schiffer in a billowing ball gown with roses in her powdered hair being embraced by her lover while her fiancé looks on, a glass of Dom Pérignon in his hand. The print will be golden: a rectangle of gold ink on 400-gram Arches paper, over which the image is printed in dense black.

2:37 pm
Jonas has brought his parents, aunt and uncle, who are visiting from Sweden, to Düstere Strasse 4 for the afternoon. He leads them through the typography level and points out Steidl, balanced on his stool in front of collapsing piles of paperwork. Flattered and slightly embarrassed, Steidl stands to greet the guests: 'Hallo, welcome to Göttingen. I'm totally busy, I have no time, but welcome.'

3 October 2008

10:19 am
Paris. Guests mill about outside the Avenue du Général Eisenhower entrance to the Grand Palais, where the Chanel Prêt-à-Porter Spring-Summer 2009 show is due to start at 10:30 am. Inside, under the forty-five-metre-high glass roof supported by a soaring network of steel girders and crowned at its centre by a French flag six metres wide, stands the set for the fashion show, a life-size reconstruction of Chanel's headquarters at 31 Rue Cambon. With its tarnished

stucco façade, awnings hoisted at different heights and wooden scaffolding on each side, the set mirrors the photo used for the invitation, presskit and badge. A 'boutique' occupies the ground floor of the set, while the runway, constructed to look like an asphalt street, extends from it. Gutters and pavements flank the street, from which tiered seating for the audience rises. The 2,200 presskits, one for each guest and delivered by Frank yesterday in Paris, lie waiting on the seats.

10:29 am

Handsome French ushers in black suits and red ties direct the guests to their seats. Front-row guests mingle on the street below: Suzy Menkes in a cerise coat and magenta scarf, Grace Coddington with her expanse of red hair, and Claudia Schiffer with a pale almond-shaped face and sleek black stockings.

10:47 am

As Madness's *Our House* begins to play, the models emerge from the boutique and walk the length of the street, alone, in pairs, in groups. The music shifts to Ladyhawke's *Paris is Burning*. At the end of the show, Lagerfeld walks the runway, followed by a flock of models.

11:24 am

The guests file out onto the real asphalt of Avenue du Général Eisenhower and Avenue Winston Churchill, presskits in hand. The set will be deconstructed this afternoon: by tomorrow no trace of it will remain under the glass roof of the Grand Palais.

6 October 2008

3:02 pm

Steidl has just returned to Göttingen from Los Angeles. He enters the typography level – *'Morgen!'* – before disappearing into a small room off his office to don his white lab coat. Steidl and Jonas have been at the Getty Villa in Los Angeles, where Steidl took photos of Jim Dine's installation *Poet Singing (The Flowering Sheets)*, with Jonas assisting. The photos will form the basis of a book on the installation, which consists of four eight-foot-high wooden sculptures carved after two ancient Greek terracotta statues of female dancers in the Getty collection, and a seven-foot-high plaster sculpture of the artist's head, all surrounded by a sprawling poem by Dine written in charcoal on the walls of the room.

3:10 pm

Several pages of *The History Book, On Moderna Museet 1958–2008,* celebrating the museum's fiftieth anniversary, must be reprinted as they contained errors. Binding of the book has, however, already begun. Bernard calls Lachenmaier and halts production until the reprinted sheets can be delivered this afternoon. Steidl and Bernard confirm that all errors are restricted to only two printing sheets.

4:44 pm

Aurélie Vandenbussche from Chanel calls Steidl and asks when the Open Doors cards for the Paris event on 15 October will be delivered. He says not before the morning of 8 October, as the cards are still to be printed. She asks if they can be delivered by 9:00 am on 8 October: Steidl confirms.

4:48 pm

Aurélie calls again: is it somehow possible to receive the cards by tomorrow morning? No, replies Steidl. She asks when the cards for the other countries will be delivered: he assures her that all will be printed and dispatched by courier tomorrow.

7 October 2008

8:58 am

The autumn sun softens the bite of the cold air. In the square around St Nikolai's church, founded in the twelfth century and facing Düstere Strasse, stand elm trees with yellowing, tear-shaped leaves.

9:27 am

Andreas Nickel, printer, moves a pallet of paper towards the Roland 700; Steidl guides the pallet, walking backwards.

12:37 pm

Paul Ruscha, Ed Ruscha's younger brother and studio manager, has sent an email concerning Steidl's recent visit to the Ruscha studio in Los Angeles and the *On the Road* project:

Count Monte's Crisco!
Gerhard called me a couple of hours ago and I immediately handed the phone to Ed so I never got to speak another word in any language to him, thereafter. But hell, it was nice while it lasted for a few seconds!

Ed just told me he'd like to change a couple of images he'd given Gerhard for On the Road. *He'd like to replace them with better ones which he's found and chosen: those to hold back on are on pages 58 A&B, and 64 A&B. Ed would also like to know when Gerhard will be coming back to LA next, and that he's going to exhibit the book in London in early October next year, and hopes he can be assured it'll be finished and available by then.*

It was wonderful to see Gerhard here in person, processing hundreds of things at the same time with those bespectacled eyes. I just hope he doesn't burn out too soon. He has a lot to accomplish! Somebody recently told me he'd had a heart problem, and that's why Rüdi watches his diet so closely. I'm glad of that – we don't want to lose our favourite task-master…

Love and tee-hee to you and all the Gerdites in Göttingen,
Paul

8 October 2008

9:11 am
Joan Lyons has arrived to supervise the printing of John Wood's *On the Edge of Clear Meaning*. Impressed and overwhelmed, she begins to take photos of Steidl's office: the towers of books, the mess of papers, the two fax machines, the dust-covered stacks of Fendi invitations on the floor. Steidl enters and exclaims, delighted: 'Oh, a tourist! An American tourist! So we start right away with the work.'

6:10 pm
Steidl has not eaten yet today – no time, he said.

9 October 2008

9:21 am
Jonas and I have just sorted Steidl's photos of Dine's *Poet Singing (The Flowering Sheets)*. The black-and-white images – of the wooden sculptures, of Dine scrawling and smudging the poem on the wall, and of close-ups of words from the poem including 'time', 'paint', 'ocean', 'rose', 'children' and 'oxen' – have been laid out on the dining room table and floor. Steidl will select photos for the book, and give them to Julia to be scanned.

10:00 am
Janette Ahrens, pre-press, is seated at Sarah's computer and has opened the layout files for Robert Frank's *Black White and Things*. Two layouts for the book

exist: one following the design of the 1994 Scalo edition with the titles, locations and dates of the photos written on the title pages of the three chapters 'Black', 'White', and 'Things'; and the other mirroring the design of *The Americans,* with each photo on a right-hand page and the corresponding written information on the facing left-hand page.

Janette is to check both documents, print them out, and construct maquettes. Steidl plans to show Frank the maquettes tomorrow to determine the book's final design, as well as discuss *Henry Frank, Father Photographer,* a book of Frank's father's stereo-photographs.

10 October 2008

9:21 am

William Ewing and Natalie Herschdorfer, of the Musée de l'Elysée in Lausanne, have arrived to discuss the exhibition 'Lasting Impressions – The Fine Art and Craft of the Steidl Book' at the museum from 17 November 2009 to 21 February 2010. I take them to the library – Polidori's 'office' – and introduce them to Polidori who is cutting out print-outs of Versailles photos with a pair of silver scissors. Coincidentally, and to their mutual delight, Nathalie and Polidori realise they have been in recent email contact about his participation in an up-coming group show at the Musée de l'Elysée.

12:41 pm

Steidl dashes into the stairwell from the typography level. He inadvertently kicks the wooden doorstop that sits by the doorframe: the doorstop scuttles across the parquet floor.

13 October 2008

9:43 am

Polidori's working materials lie in overlapping heaps on the two large tables in the library and include: hundreds of colour print-outs of Versailles photos; an empty FedEx box; scattered paper clips; a pot of Mariage Freres Marco Polo tea; a jar of honey on a ceramic saucer; and four CDs in scratched plastic cases, three by Michel Jonasz and one by Francis Cabrel.

11:40 am

Maria Elena Cima, advertising and image graphic manager at Fendi, calls to ask

if Steidl will attend the upcoming advertising campaign shoot by Lagerfeld in New York for the women's Spring-Summer 2009 collection: he confirms.

14 October 2008

9:29 am
Sarah approaches her desk, where piles of paper and maquettes greet her. *'Guten Morgen,'* she says to Steidl, to which he grumbles a reply.

12:09 pm
Polidori needs a package to be wrapped: Steidl does it himself.

3:06 pm
Sarah has begun designing Joan Mitchell's *Sunflowers* for Cheim & Read gallery in New York: drips and patches of agitated colour illuminate her computer screen.

15 October 2008

3:59 pm
Marion Chauvin from Chanel calls to ask whether the *Mademoiselle – Coco Chanel / Summer 62* books will be delivered on 15 November. *Mademoiselle* features candid photos by Douglas Kirkland of Coco Chanel in Paris in 1962: crossing the street from her suite at the Hotel Ritz; laughing on the sofa in her apartment at 31 Rue Cambon; pinning an armhole during a fitting, with a Kent cigarette dangling from her lips; watching a fashion show from the famous mirrored staircase. Lagerfeld will design the book as well as write the introduction and captions for the images.
Work on *Mademoiselle,* however, is yet to begin. Steidl explains to Marion that he cannot discuss the book with Lagerfeld at present as he is preoccupied with a Chanel accessories campaign, but hopes to be able to do so during the PAP SS09 advertising campaign shoot in Vermont. Chanel has ordered a quantity of *Mademoiselle* books as Christmas presents. Steidl confirms the books will be produced and delivered on time.

4:35 pm
Steidl's fax is playing up, resulting in a comical series of test-faxes being sent between Steidl, Bernard and Matthias in a flurry of electronic beeps. The tests are unsuccessful. Confused but determined, Steidl stands in the packing room,

hands on hips, studying an intimidating tangle of telephone cables which he hopes might offer a solution.

4:47 pm

Polidori is departing again for Versailles: a car has arrived to take him to Frankfurt airport. His baggage – a large plastic suitcase covered in grubby stickers, an overfilled black computer bag, and a double-handled canvas bag – sits on the red bricks of Düstere Strasse. A ruffled Polidori emerges from the Günter Grass guest apartment at Düstere Strasse 5, kneels down beside the car, and begins to rummage through his bags. Soon after, the driver helps him into the car and they depart.

16 October 2008

6:15 pm

Steidl has caught the train to Frankfurt to celebrate Günter Grass's birthday. Grass is attending the Frankfurt Book Fair, from 15 to 19 October, and tonight there is a dinner to honour his eighty-first birthday. Steidl will travel back to Göttingen tonight by car with Frank, work tomorrow, and return to Frankfurt tomorrow evening to host his annual dinner at the fair for a small group of authors, sales representatives, employees and colleagues.

17 October 2008

10:53 am

Sophie calls Steidl to discuss the invitation and presskit for Chanel's *Paris-Moscou* 2008/9 fashion show, to take place at the Théâtre le Ranelagh in Paris on 3 December. She emails Steidl a preliminary image for the presskit, based on a Russian Constructivist poster. Paris-Moscou takes Russia as its theme and is Chanel's 2008 *Métiers d'Art* presentation, an annual collection indulging the workmanship of the Parisian ateliers that create decorative specialities for couture houses including embroidery, artificial flowers, feathers, costume jewellery and millinery.

6:00 pm

Sophie cannot reach Steidl as he has left for Frankfurt. She has just received materials for the Paris-Moscou invitation, a CD containing Quark documents and a 40 x 60 cm drawing for colour reference, which need to be brought to Göttingen. She asks if Steidl has a driver in Paris at the weekend to pick up the materials.

8:16 pm

Steidl is hosting the annual dinner at the Maritim Hotel, Theodor-Heuss-Allee 3, Frankfurt. The Maritim is a business hotel with a squat, curved façade, and was built in 1996 opposite the convention centre where the book fair takes place. Tonight, taxis queue outside its entrance where smokers stand, cigarettes in hands. The Japanese restaurant SushiSho occupies a corner of the hotel lobby, from which escalators rise to a level with several function rooms, each named after a different German city: 'Berlin', 'Köln', 'München'. At the top of the escalators stand smiling hotel employees in white shirts and dark waistcoats pinned with metallic nametags.

The partition between the Berlin and Köln rooms has been removed for the dinner. The guests mingle while sipping sparkling wine or orange juice. Before them stand tables decked in white and scattered with autumn leaves, chestnuts and berries. Baskets of sliced bread sit beside little dishes of butter.

I am slightly flustered when I enter the room, as dinner was due to begin at 8:00 pm. Steidl is dressed in grey jeans, a black jacket and black leather boots – no white lab coat in sight. I explain to him that Sophie has materials for the Paris-Moscou invitation. I then talk to Frank who is fumbling with a chestnut on a table with an orange gerbera in a vase at its centre. He is looking forward to tomorrow, a Saturday on which he does not have to work – he has even made an appointment to have his hair cut. Steidl approaches us and asks if we have Sophie's mobile phone number. I give him the number and he steps outside to call her.

Melanie Heusel, a new editor for the German literature programme at *Steidl*, joins Frank and me. She is buoyant, despite her bag having being stolen from the fair stand today.

8:17 pm

Grass arrives with his wife Ute: dinner begins. The entrée of smoked trout on pumpernickel is served, followed by lentil soup, sauerbraten with mashed potatoes and sauerkraut, and apple strudel with vanilla sauce (no ice cream on Steidl's wishes).

8:37 pm

Steidl approaches Frank's chair, and talks softly in his ear.

8:47 pm

After the entrée, Steidl stands and taps his fork against his wine glass, creating a ringing sound that gradually silences the room. He addresses the guests, thanks them for attending, and praises Grass's *Tin Drum,* which will celebrate its fiftieth anniversary in 2009.

After Steidl's speech, the convivial and relaxed Grass responds. With his deep tobacco-coloured voice, he says how he delights in being over eighty years old. He reminisces about bringing *The Tin Drum* to the Frankfurt Book Fair for the first time in 1959, and how the landscape of the fair has changed irrevocably since then. Finally, he admits with candour and self-humour how well he is able to nap in the afternoons but that he sleeps less well at night.

After Grass's speech, jokes circulate about potential fiftieth-anniversary editions of *The Tin Drum,* including selling the book with an actual tin drum.

9:09 pm

Steidl slips out of the room before the main course has been served; dinner continues without him. Frank is already waiting in the hall outside. He will now drive Steidl back to Göttingen and continue tonight to Paris, where he will pick up the materials for the Paris-Moscou invitation. He will call the hairdresser to-morrow morning from Paris to cancel his appointment.

20 October 2008

3:52 pm

I ask Katharina playfully if Sarah is her role model. Katharina laughs and replies yes, Sarah is her 'big typography sister'.

4:35 pm

Claire Keegan has arrived in Göttingen to read at the literature festival *Göttinger Literaturherbst* 2008, from 17 to 26 October. Claudia is showing Keegan and the German translator of her work, Hans-Christian Oeser, through the warren of Düstere Strasse 4. (*Steidl* published a German translation of Keegan's collection of short stories *Antarctica* in 2004, and will release a translation of *Walk the Blue Fields* this year.)

Keegan is tall and has a round, porcelain-coloured face, blue eyes and dark red hair parted in the middle. Her first and only sight of her German publisher is from behind, tapping at his typewriter.

21 October 2008

3:08 pm

Autumn rain falls, the type that is carried by the wind like snow. Employees at the toy store Karstadt Spielen und Lesen on the corner of Düstere Strasse and Groner Strasse are wheeling out decorative Christmas trees, dark green plastic cones strung with electric lights.

4:40 pm

Steidl collects the plastic bins brimming with paper on the typography level, places them into the goods lift next to the stairwell, and sends them down to the ground floor to be emptied by one of the printers. Within a few minutes the bins return empty, and Steidl restores each to its designated home: one under his desk, another behind Bernard's chair, another in the packing room.

22 October 2008

8:59 am

Julia is standing at the photocopier outside Steidl's office. With a cheeky grin, Steidl sidles towards her with a sheet of paper in his hand and asks, like a schoolboy, if he might push in front.

10:47 am

Steidl tells Sarah there is an hour left to prepare the Robert Frank dummies, before he departs to the airport. In the rush Katharina lends a hand. I wrap the test-prints of the Paris-Moscou presskit and invitation for Steidl to take with him.

1:48 pm

Steidl has departed for Frankfurt on the train; his flight to New York leaves at 5:00 pm.

6:22 pm

Marc Schmidt, in-house carpenter, has constructed a temporary worktable next to the Roland 200 by placing a large wooden board on two pallets of paper. Here he is packing the Chanel Christmas wrapping paper that is currently being printed on the Roland 700. 600 packs containing 100 sheets of small paper (50 x 65 cm), and 600 packs containing 100 sheets of large paper (100 x 65 cm) have been ordered, and will be used by boutiques to wrap purchases bought in the approach to Christmas. The paper is tissue-like, pale grey and translucent.

23 October 2008

10:34 am

Steidl has arrived in New York for the Fendi SS09 shoot; the office is quiet in his absence.

11:13 am

Sarah has begun designing the Dom Pérignon Diary 2009, a small notebook that *Steidl* produces annually. Steidl called her from Frankfurt airport yesterday afternoon with instructions for the diary: it is to have 192 pages, be of A6 size, and have horizontal grey lines printed on the majority of its pages for writing notes, interspersed with colour images showing different moments from Dom Pérignon's history. These include a photo of the abbey of Saint-Pierre d'Hautvillers in Champagne where the Benedictine monk Pierre Pérignon directed wine production from 1668 until his death in 1715; François Boucher's *Portrait of Madame Pompadour* (1756), depicting the sumptuous and educated mistress of Louis XV, a patron of champagne; and a 1962 photo of Marilyn Monroe cradling a glass of champagne from Bert Stern's 'Last Sitting'. Each diary will be bound in black leather, embossed with silver lettering, and have a black cloth bookmark.

24 October 2008

11:28 am

The birch trees visible through the window behind Bernard's desk have lost their leaves: their bare branches sway in the cold air.

27 October 2008

9:24 am

Tacita Dean has arrived from Berlin. She has a kind face, and her dark greying hair is fixed with a twist at the back of her head. She, Steidl, Katharina, Sarah and Jonas go to the library to discuss the two books Tacita has come to complete: *Darmstädter Werkblock* and *Teignmouth Electron*. Both publications concern the passing of time and human absence. *Darmstädter Werkblock* contains stills from a film Tacita shot of the seven rooms housing Joseph Beuys's installation *Block Beuys* (1970–86) at the Hessisches Landesmuseum in Darmstadt. When Beuys made the installation, the walls of the rooms were covered with jute, and the

floors with carpet. The decision to remove these materials during the renovation of the museum in September 2007 – under the pretence that they were not part of *Block Beuys* but merely aspects of the room's decor – was controversial for those who believe that the jute, carpet, and their deterioration are integral to the installation. The film-stills show the walls, floor and other details of the rooms just prior to renovation, without depicting *Block Beuys* itself. *Darmstädter Werkblock* will be a numbered, signed edition of one thousand books.

Teignmouth Electron tells the story of amateur yachtsman Donald Crowhurst, who was lost at sea in the 1968 Sunday Times Golden Globe Race, a solo around-the-world yacht race. Crowhurst's boat, Teignmouth Electron, was discovered empty and adrift in the Atlantic Ocean (he abandoned the race, although forged documents suggest his continued participation in it). The book combines a collection of texts by Tacita outlining the story with her photos of the yacht in its present state: plundered and rusting on a beach on Cayman Brac in the Caribbean.

1:16 pm
Tacita is seated next to Katharina, working on text corrections; Melanie is proofreading the text for *Teignmouth Electron;* Sarah is working on its design. 'Keeping them all busy?' asks Steidl with a grin.

28 October 2008

9:03 am
Steidl calls me into his office to discuss two articles he is writing: one for *The Journal,* the other for *HE* magazine. *The Journal* has requested eight to ten short book reviews from Steidl. His idea is to describe a shopping spree during which he buy books for a fictional journey – both for himself to read while travelling, and as gifts for friends at the destination. *HE* has asked Steidl to write about a personal obsession. Steidl has chosen to describe the culture of the fax, his favourite method of communication.

11:46 am
Steidl complains he has spent his day since 5:00 am correcting the mistakes of others and has had no time to accomplish any substantial work.

1:29 pm
Tacita enters Steidl's office: 'Gerhard, I have a question.' He responds, *'Ja,* make it with Sarah.'

4:45 pm

Steidl's mood has improved: he buzzes through the typography level collecting the different boxes containing materials for Tacita's books.

5:06 pm

It is nearly dark: through the windows the sky is deep indigo, fading into black.

5:23 pm

Tacita is working on colour corrections at the light table outside the digital darkroom: she approves the colour-accurate proofs, and indicates corrections to be made on others with a red permanent marker.

29 October 2008

12:30 pm

Steidl is in a buoyant mood despite the rush to prepare for his departure to-morrow to Burlington, Vermont, for the Chanel advertising campaign shoot.

30 October 2008

9:04 am

Steidl has arrived at Frankfurt airport for his trip to Vermont. He checks in to Lufthansa flight LH 9640 to Montreal, departing at 11:10 am. (Once in Montreal he will rent a car and drive the 165 km to Burlington.) Steidl collects his board-ing pass and proceeds to the Lufthansa lounge to await departure.

9:29 am

Steidl suddenly changes his mind: he approaches the booking desk in the corner of the lounge and informs the employee there – Frau Breucha, a middle-aged woman with blonde hair, pearl earrings, and a navy-blue uniform edged with yellow – that he would like to cancel his flight, and instead fly on Lufthansa's LH 400 to New York at 10:15 am today. (He then plans to fly with JetBlue from New York to Burlington.) Frau Breucha is both flustered and excited by the ur-gency of Steidl's request. Pearl earrings glinting, she cancels the flight to Montreal on her computer, and dials a number to organise the ticket to New York.

9:42 am

Despite her efforts, Frau Breucha is unable to book the flight to New York be-cause the departure time is too close: Steidl will have to arrange the flight from a larger booking desk in another part of the terminal. She apologises and leads

an irritated Steidl to the desk. There she apologises again, before disappearing into the currents of people.

9:54 am

Frau Nicklaus, the inexperienced employee in her mid-twenties at the booking desk, informs Steidl that the 10:15 am flight has already closed. His eyes twinkle as he considers an alternative plan of action. Within a minute, he says he wants to be rebooked on the original flight to Montreal he had cancelled earlier this morning. Frau Nicklaus's fingers flit across her keyboard in response, but she regrets that this too is not possible – Steidl's seat has been given to a passenger on a waiting list. At this news, his irritation increases as well as his determination to find a solution.

10:14 am

Steidl now asks for details of the next Lufthansa flight from Frankfurt to Boston. He decides on flight LH 422 at 12:15 pm, and then to rent a car in Boston and drive the 348 km to Burlington. At this request Frau Nicklaus realises she is out of her depth and seeks assistance from a supervisor. A man with rimless glasses, a bald head, and a calm demeanour appears swiftly at her side. He ensures Steidl he will not miss the flight.

11:47 am

Yet another Lufthansa employee escorts Steidl to the departure gate for LH 422 to Boston. He boards the plane, which lifts into the air on time.

1:23 pm

Steidl lands in Boston, rents a blocky sky-blue American sedan with a pale leather interior and drives to the Hilton Hotel at 60 Battery Street, Burlington, without stopping.

5:17 pm

Steidl checks in to the hotel and parks his car. Lagerfeld and his crew are not at the hotel but still shooting at a nineteenth-century red-brick house on Grand Isle, forty minutes away. Steidl takes a seat in the lobby and awaits their return.

31 October 2008

9:37 am

Steidl is on Grand Isle, watching the shoot. The model Heidi Mount, dressed

in a black jumpsuit with cream organza sleeves, walks across the groomed green lawn stretching from the house to the shore of Lake Champlain as Lagerfeld follows her with his camera. Black ribbons on the jumpsuit flutter in the wind.

11:48 am

Mount prepares for the next photo with the help of a stylist. During the break, Lagerfeld sits at a table in the garage next to the house and sips from a large glass of Pepsi Max. Steidl takes a seat next to him, unpacks a maquette of *Mademoiselle*, and passes it to him. Lagerfeld leafs through the book with gloved fingers, occasionally pulling down his sunglasses to look with naked eyes at the images of Coco Chanel on the pages before him. He approves the sequence of photos in the book, chooses a dark grey linen for the binding on the spine, and promises to write the captions for the images on his return to Paris.

12:22 pm

Lagerfeld photographs Mount in a long tulle skirt dotted with embroidered camellias, standing by the window of an upstairs room in the house. The room is small, so the hair and make-up crews wait outside, standing in the hallway or seated on the staircase. Baptiste Giabiconi sits on a chair, waiting to be called for the next shot. A yellow-handled mop in a plastic bucket rests against the wall beside him.

12:39 pm

Lagerfeld finishes photographing Mount, enters the hallway and immediately begins to photograph Giabiconi, who directs his gaze away from the camera. An assistant lunges to remove the yellow-handled mop, fearing it to be an unwanted element of the composition. Lagerfeld asks that it be left in place.

Amanda Harlech

Ithaca, 19 August 2009

Gerhard waits. He is infinitely patient. He is good at waiting. He is an angler for an image or a phrase. Sometimes waiting is when he feels most alive, waiting for his presses to pound through their run. He is happiest in that solitary northern dawn when his cloistered publishing house is vacant, visited only by a wind that strays through the branches of his apple tree and the trestle tables are bare and the offices in darkness. Pigment stains the air leavened with paper: he moves quickly now, sniffing the woad in the ink. Gerhard knows the scent of every book. Each page turned delicately between thumb and forefinger secretes its history hardwired beneath the grave of its font. Gerhard inhales another world where meanings are shaped on paper faces. He seems most at ease in this universal whiteness, watching colours bleed to perfection or a border of gold charge a crimson binding. Sometimes I feel the imprecision of flesh disappoints him.

Books are his offspring. He is guarded, protecting their inception, selecting their DNA like a maddened in vitro professor in a white lab coat, pens ranked in a breast pocket, eyeglasses reflecting the blank page. Once I watched him tease a ream of paper into life, his thick fingers gently rubbing the weft hidden in its surfaces. His practised hand knows the degree of gloss or grain, of ancient pulp and laser technology.

At the still point of fashion's catherine wheel, on a shoot with Karl Lagerfeld, he can be found curled up asleep in a corner, or standing alone chewing the stub of his pencil as he hovers over his miniature notebook of things not to forget. An angel could levitate naked off a bed of ice but Gerhard would be unsurprised, he is slid beyond into a different set of possibilities. He told me once that his ideal holiday would be sailing on an icebreaker off the coast of Greenland. Alone. But at five in the morning when the studio circus departs and Karl is refining the order of images, Gerhard reawakens, connected again to the vocabulary of the page.

He is a guardian of paper's pedigree, a conduit for the potent image, an instigator of the timeless edition that will outlive us all.

Karl Lagerfeld

Ramatuelle, 23 August 2009

Gerhard Steidl may have no detailed knowledge of dressmaking, but I also have no precise idea about the way he works. His innovative methodology and technical vocabulary are notoriously obscure secrets for me. I know his aims, what he wants to accomplish, but don't ask me how he does it all.

His main ethical law is to produce beautiful work. He is always striving towards the new: new writers, new photographers and new machines to produce or reproduce their work to perfection. He is in love with his machines, the latest most perfect models available.

Printing is different now from the old (not so old) days of his beginnings, the machines having become more and more sophisticated. That's also one of the reasons why there are so many unnecessary and ugly books out there: they are not expensive to produce. But Gerhard is an eclectic socialist elitist. He wants beautiful books for everybody. The way they look and what they are about.

He hates it when books become too expensive. He also hates the superficial concept of books just being beautiful, dead objects on the coffee tables of people who don't read a lot and hardly look at such books, being too big and heavy to be easily handled.

He wants people to love and understand everything about a perfect book: the inside and outside. What it shows and what it wants to say. He loves the objectification of the pleasure connected with direct perception but also the artisanal craft. For him a book should be a synthesis of sensations and qualities – all kinds of qualities.

But don't forget: there is no beautiful book without beautiful paper! We are both paper-freaks and our passion for it will never die.

We should never refrain from doing what we do (what we have the chance to be able to do) with such passion.

Fashion and books are supposed to accomplish something in the world of appearances (books perhaps on a different level), but governed only by the strict laws of our conscience. Our ethical laws should only be the constant striving to do something as well as possible.

For Gerhard Steidl there is no final goal to striving. His permanent striving is his deep belief in what he wants to accomplish. Fichte wrote: 'Don't say: "What makes us happy is good," but rather: "What is good makes us happy."' That is the secret of Gerhard's happiness.

November 2008

3 November 2008

10:30 am

Adeline Pelletier from the Fondation Cartier pour l'art contemporain has arrived in Göttingen to complete Raymond Depardon's *Here Them Speak* for his exhibition 'Terre Natale, Ailleurs commence ici' from 21 November 2008 to 15 March 2009 at the foundation. Sarah Greenough from the National Gallery of Art in Washington, DC, has arrived to print *Looking In: Robert Frank's The Americans* for an exhibition of the same name at the gallery from 19 January to 26 April 2009.

4 November 2008

10:00 am

The new intern Jonas Marguet, dubbed 'Jonas deux' by Steidl, is making a maquette of David Bailey's *8 Minutes* for Steidl to show Bailey next week in London. *8 Minutes* features one hundred and thirty photos of Damien Hirst taken by Bailey in a single sitting of eight minutes ('actually seven and a half' admits Bailey). The photos are frontal depictions of Hirst's face, each showing a different spontaneous expression: mouth open in mid-scream, fingers pulling at cheeks, laughing hysterically.

5:51 pm
Sarah refines the design of the Dom Pérignon Diary. A suggestion to place the images at postage-stamp size at regular intervals among the grey lined pages has been scrapped: each image will now be full-page.

5 November 2008

2:02 pm
Steidl is planning a trip to Doha on 19 November to discuss a book project with Khalid Bin Hamad Bin Ahmad Al-Thani. The book, *Here is My Secret*, will contain Al-Thani's photos of the Qatari landscape including sand dunes, gazelles, falcons and night skies.

6 November 2008

9:34 am

Looking In: Robert Frank's The Americans is being printed on the Roland 700. Steidl, Bernard and Bob Hennessey, who made the separations for the book, are discussing which printing plates need to be remade. (Hennessey intended that a pale grey appear in the background of certain pages, but it has been absent on the sheets printed so far.) Bernard is preparing a new layout file to address the problem. Steidl explains to Hennessey how time-consuming and intricate printing has been for the book – that it is more complicated than anticipated and how the removal and washing of printing plates is labour-intensive.

Steidl plans the work to be completed on *Looking In* before Hennessey's departure on 8 November. Tomorrow, Steidl will conduct wet-proof printing for the book and asks Hennessey if this might be done without varnishing forms, which would save about an hour. Hennessey deliberates before deciding to include the varnishing forms.

1:30 pm

As Sarah collects her coat on her way out to lunch, she finds a small plate of apple pieces sitting on a pile of print-outs. She assumes the plate belongs to Steidl, as Rüdiger Schellong, Steidl's chef, sometimes prepares fresh apple for him to eat while working: crescent-shaped pieces arranged in a ring, sprinkled with lemon juice to prevent the flesh turning brown. Sarah picks up the plate and offers it to Steidl. He happily takes a piece of apple – although the plate is not his – and asks if today is perhaps Sarah's birthday, puzzled as to why she is distributing gifts.

7 November 2008

2:32 pm

Lagerfeld has faxed Steidl his captions for the *Mademoiselle* book. These include: 'the mythic staircase' for a photo of Coco Chanel ascending the mirrored staircase at 31 Rue Cambon, 'the famous fitting of the sleeve' for an image of Chanel adjusting a garment with pins, and 'Bettina Graziani and Art Buchwald' for a shot of guests mingling after the fashion show.

3:12 pm

Sarah has bought a box of mandarins and distributes the fruit to those on the typography level.

3:28 pm

Polidori has returned to Göttingen with scans of new photos taken recently at Versailles: 'I hope I survive this – this book is a nuclear bomb.'

17 November 2008

10:09 am

Lewis Baltz has arrived from Venice to plan eleven upcoming books of his work. He has a soft, kind voice, and ascends the stairs of Düstere Strasse 4 slowly.

12:36 pm

Bernard and Steidl discuss the production of the DVDs for the Paris-Moscou presskits. Unlike the standard presskits that simply consist of a folder containing loose printed photos, each Paris-Moscou presskit will also contain a DVD of *Coco 1913 / Chanel 1923*, a black-and-white film by Lagerfeld exploring Coco Chanel's indulgence in Russian émigré society in Paris in the 1910s and '20s. The film is currently being shot in Paris, and will be shown at the fashion show on 3 December. A master DVD of the film will arrive in Göttingen on 28 November to be duplicated and inserted into the presskits. Nine hundred and seventy-five presskits including DVDs are then to be delivered in Paris on 2 December. Bernard would prefer the master to arrive on 27 November, as it is unclear whether the DVDs can be produced over the weekend of 29 and 30 November.

12:42 pm

Sarah is fine-tuning the three book covers and slipcase that will present Polidori's *Parcours Muséologique Revisité* in the *Steidl* SS09 book catalogue. The photo on the slipcase shows an external view of a wing of the palace at Versailles, clad in scaffolding. The photos on the book covers depict various doors inside the palace: the first is covered in worn white paint, the second is a hidden door built into a wall lined with magenta wallpaper, and the third has wooden panels framed in tarnished gold leaf.

'I'm finished!' says Sarah, and Steidl comes to inspect. He stands with his arms crossed before her computer screen: 'Start from the top ... that doesn't interest me ... a little lower ... perfect!' He dictates technical information about the book for Sarah to type up: 'Book design by Robert Polidori and Gerhard Steidl, Volume 1: 240 pages'. 'Mousie!' he exclaims on seeing Sarah mistakenly type 'volumen' instead of 'volume'. She laughs, saying her Latin is better than her English.

4:39 pm

Steidl has left the office without a word; no one knows his whereabouts. His white lab coat hangs on his chair.

4:50 pm

Jan, Melanie and Sarah are delighted with Sarah's design for the dust jacket of one of the German novels to be released in the Spring-Summer 2009 programme, Ruth Johanna Benrath's *Rosa Gott, wir loben dich*. The dust jacket consists of a black background on which each word of the novel's title is capitalised and occupies a separate line in a different colour: yellow, red, blue, green and orange. The overall effect is of a downsized poster, where each word rings out with its own meaning as it resounds with the other words of the title.

18 November 2008

12:06 pm

Jan, Claudia and Melanie huddle around Steidl on his stool, discussing Günter Grass's *Unterwegs von Deutschland nach Deutschland. Tagebuch 1990* ('From Germany to Germany and Back Again: Diary 1990'). Jan is currently copy-editing the manuscript, which must be ready for Grass's visit to Göttingen on 15 December when the book will be designed and typeset. *Unterwegs* is Grass's diary from 1990 and documents his experiences leading up to and after German reunification on 3 October 1990.

1:01 pm

Lagerfeld's photos from the Chanel shoot in Vermont have arrived. Judith prepares a set of proofs for Steidl to take to Paris for colour correction. The photos take as their inspiration the work of Danish painter Vilhelm Hammershøi: domestic interiors of lone women in muted, almost cold, colours. Lagerfeld portrays Heidi Mount in a variety of hushed, absorptive states: gazing out an unseen window, seated on a staircase, studying her reflection in a mirror. The colours of the campaign are subdued without being sombre, ranging from black, greys, beige, creams, to soft pink, each hue made visible by the pale Vermont light.

4:29 pm

Baltz waits at the entrance to Steidl's office. Steidl apologises for having little time today, and calls Julia upstairs to discuss the insurance of Baltz's photos to be sent from Göttingen to the Fotomuseum Winterthur.

6:05 pm

Stefan Erfurt, founder of C/O Berlin, has arrived; Elisa Badii, coodinator of *Steidl*'s photography programme, is giving him a tour. He asks when copies of Jerry Berndt's *Insight* will be ready from the bookbinder.

19 November 2008

10:44 am

Steidl is on the train to Frankfurt, from where he will depart today to Doha. Julia, curious, looks up Qatar on the internet and discovers it is a remarkably small country – a peninsula in the Persian Gulf only 180 by 80 km – but rich in natural gas reserves. Sarah wonders if Steidl is visiting a sheik.

3:42 pm

Steidl calls from the plane to Doha; it is a crackly connection. He talks to Sarah and Jan on speakerphone: they lean forward to better understand him through the crackling. He explains there is to be a new student edition of Grass's complete works including his novels, essays and speeches. The edition consists of twenty hardcover books in a white cardboard box to be adorned by one of Grass's drawings. Steidl vetoes using the famous drawing of Oskar Matzerath from *The Tin Drum*, as it will be overexposed in the press for the book's fiftieth anniversary in 2009; Jan concurs.

5:33 pm

Sarah and Jan flip through possible Grass drawings for the cardboard box: a smug rat reading a book, a self-portrait as a chef, a wolf, a hand holding a quill.

20 November 2008

10:30 am

The sales conference for the approaching Spring-Summer 2009 season is about to begin in the library. Claudia and Jan are dressed more formally than usual for it: she in a skirt suit and leather shoes, he in an open-collared shirt and jacket. Monika Müller, *Steidl*'s sales representative for Germany's largest bookshops, has arrived from Berlin for the conference and brought little potted plants as gifts for her Göttingen colleagues.

The conference takes place every six months, in anticipation of the Frankfurt Book Fair in October and the Leipzig Book Fair in March. It is an occasion for

the sales representatives for German-speaking countries to discuss the titles to be released in the upcoming season.

10:57 am
A CD containing Lagerfeld's photos of the Fendi SS09 advertising campaign has arrived. Judith calibrates the files and prepares a set of proofs for Steidl to take to Rome next week for colour correction.

12:36 pm
The weather is stormy: the rooftops are wet and the wind rattles the horizontal metal blinds outside Jonas's window.

1:26 pm
There are complications with the *Mademoiselle* books. Steidl has promised that the quantity ordered by Chanel will be delivered to the logistics hub in Chamant either on the evening of 24 November or early on 25 November.
The books have been printed and the sheets are already at the bookbindery, which has confirmed that the bound and packed books will be ready for collection on the morning of 24 November. The bindery cannot begin work however, as it has not yet received the covers of the books, which are being laminated by another company. Bernard asks me if there is a concrete delivery date for the books and I reply yes – Chanel will be sending them as Christmas gifts. He calls both the bindery and lamination firm, explaining the urgency of production. The lamination firm states it received no instruction as to when the job had to be completed, but can nevertheless meet the deadline. Bernard tries to reach Steidl on his mobile without luck: he is difficult to contact while in Doha.

4:22 pm
Rüdi brings down a large bowl of vanilla yogurt with raspberries, left over from the sales conference, for those on the typography level to share: each takes a teaspoon.

6:51 pm
Holger Michaelis, IT manager, sits in silence before the glare of Jonas's computer screen. His fingers move at a slow, measured pace across the keyboard as he installs a programme.

21 November 2008

9:36 am

Steidl calls from Doha with two requests: that the list of guests for the Steidl Artists' Party on 11 December be faxed to him, and that Judith prepare two sets of proofs of the Fendi campaign – one for Steidl to take to Rome on 25 November, the other for him to show Lagerfeld on 26 November at the Paris-Moscou presskit shoot in Paris.

24 November 2008

9:28 am

It is snowing for the first time this year: whiteness coats Göttingen's rooftops.

9:47 am

Michael Mack, *Steidl's* managing director based in London, and head of the imprint SteidlMack, has arrived in Göttingen to finalise the SS09 catalogue.

10:02 am

Donovan Wylie calls Steidl to schedule his visit to Göttingen: not within the next two weeks is the answer.

10:14 am

Steidl asks Elisa who will prepare the backlist for the SS09 catalogue: she suggests Jonas deux.

12:17 pm

Steidl, Michael, Katharina and Elisa make final touches to the catalogue: substituting picture material, tweaking typography, altering book prices.

6:32 pm

Steidl recounts a story from his last visit to Doha. Whenever travelling overseas, he wears two watches, one on each wrist. The watch on his left wrist is set to Göttingen time; the watch on his right wrist shows local time, depending on his destination. A sheik in Doha noticed Steidl's watches and asked him of their purpose. He was impressed with the answer: that the two watches enable Steidl to efficiently conduct business in Germany while overseas.

The next morning, Steidl met the sheik again and noticed that he – as well as other sheiks present – was wearing a watch on each wrist, both Rolexes.

25 November 2008

9:11 am

Steidl is at Palazzo Fendi on Largo Goldoni in Rome to discuss the proofs of the SS09 campaign. He will return with potential corrections to be incorporated into the proofs for Lagerfeld.

26 November 2008

10:23 am

The Paris-Moscou presskit shoot will take place tonight on the ornate Pont Alexandre III, with its bronze statues of cherubs and clusters of electric lamps in Paris's eighth arrondissement. Frank has just left for Paris by car, and on arrival will check in to the Hotel Castille at 33–37 Rue Cambon. He will sleep at the hotel this afternoon and evening, before collecting Steidl – who flies to Paris this afternoon – from the shoot when it concludes early tomorrow morning. Together they will return to Göttingen with a DVD of the presskit photos.

The photos will be both calibrated for printing and printed tomorrow, for assembly into the presskit folders and delivery to Paris on the morning of 2 December. Each guest at the Théâtre le Ranelagh on the evening of 3 December will be welcomed by a presskit on his or her red velvet seat.

27 November 2008

8:57 am

The fluorescent lights on the typography level are still to be switched on: Steidl and Frank have not yet returned from Paris.

9:01 am

Bettina Hoppe and Jessica Pabst, accounts and bookkeeping, are urgently trying to contact Steidl about an unpaid invoice. Bettina calls his mobile without success. She calls Frank who answers in a hushed voice: they are still in the car and Steidl is asleep.

9:28 am

Claudia walks through Steidl's office to collect her mail, a healthy bundle of letters on a cluttered desk at the back of Elisa's office. Steidl personally collects and sorts the incoming mail of his employees.

9:31 am

Rüdi pokes his head into the typography level and, curious as to how many guests he should prepare lunch for, asks when Steidl is expected to return.

11:09 am

Frank bursts in with Steidl's bags and an unexpected level of energy after his seven-hour drive: *'Bonjour!'* He has brought two DVDs with him: one for Judith with the presskit photos, the other for Bernard containing the film *Coco 1913 / Chanel 1923* to be duplicated and inserted into the presskits.

Frank says the shoot finished late, and that he and Steidl left Paris at 4:00 am. The weather was frigid on the Pont Alexandre III during the shoot; the wind whipped down the Seine. To prepare the model Sasha Pivovarova for each shot, the crew moved back and forth between the bridge and the studio in Rue de Lille in two Hummers and an Audi Q7.

Steidl himself is yet to return to the office but may be irritable on arrival, as the workload today will be particularly heavy: not only do the Paris-Moscou photos need to be calibrated and printed, but Fendi has requested that the final colour proofs for the SS09 campaign, as approved by Lagerfeld yesterday, be sent to Rome today.

11:36 am

Steidl enters the office: *'Morgen!'*

1:49 pm

Steidl is on the phone to Sophie discussing the presskit photos, of which there will be an unusually large number: twelve. Production will be further complicated as the sheets are to be printed on both sides: Lagerfeld's photos on the front, and one of the Russian Constructivist posters in beige, red and black on the back.

1:57 pm

The 2,480 Paris-Moscou presskit folders that were printed and varnished last week in anticipation of the photos to be inserted into them, must now be discarded and reprinted. An error has been discovered, unfortunately late, on the back of the folder that shows a poster design incorporating a large red '5', 'Chanel', 'Paris-Moscou' and '2008'. The outlines of these letters and figures appear a little blurred, as if they had been printed on top of one another twice, each time aligned slightly differently. The source of the error is as yet unknown.

28 November 2008

10:29 am

Steidl assures Sophie that the new presskit folders will be produced in time for delivery in Paris on 2 December.

10:37 am

Steidl and Sarah finalise the page count of the *Steidl* SS09 book catalogue: 'I don't like these pictures,' he says, 'they look like cosmetics advertising.' When the page count is final, Sarah will send the catalogue as a PDF to Michael Mack, who will compile the index. Finally, Melanie will proofread the document and provide the definitive approval to print.

11:11 am

Work has been begun on the Spring-Summer 2009 German literature catalogue, the smaller German-language sister to the English-language international book catalogue. Each German catalogue presents the season's literature titles as well those international photo-books deemed most fitting for the German-speaking market.

1:45 pm

Juergen Teller's photos for the Vivienne Westwood Spring-Summer 2009 advertising campaign have arrived. The images will be colour-corrected and proofs sent to Teller for approval. There are thirty-seven images in total: twenty-eight for the campaign, and an additional nine for inclusion in the book *Election Day,* based on the photo shoot.

The photos feature Pamela Anderson, Vivienne Westwood and her husband Andreas Kronthaler, and the Queens of the Stone Age cavorting in a laundrette, driving a golf cart and posing in the parking lot of a Los Angeles trailer park. Individual compositions include a bespectacled Anderson with a bird of paradise flower between her teeth; Anderson reading a paperback of Plato's *Republic,* her nipples visible through sheer fabric; and a perplexed Westwood standing before a wall of washing machines in yellow high heels with black hearts over the toes.

Lewis Baltz

Venice, 7 February 2009

I first met Gerhard in the late summer of 1993, when I came to Göttingen to approve the press proofs for *Regel ohne Ausnahme*, the German version of my book *Rule without Exception.* Though it seemed rather simple on the face of matters – reprint the American edition with German text, add one new form and *voilà!* a new book – it was in fact much more complicated than I'd imagined.

To start with, when the films arrived from the US it was clear they belonged to a different process to that which had been used in Germany for the past dozen or so years. No one working at *Steidl* at the time had used this system. Gerhard tracked down a printer, long since retired, who could work with these films. So the first crisis passed before I arrived.

Steidl then was not what it later became. The pressroom had only one two-colour press. The results of printing four-colour this way, wet on dry, meant the colour was extraordinary: no one but a specialist could tell how the final work would be. And then there was the question of drying time.

My project was already under severe time pressure when I arrived, which Gerhard solved by renting the four-colour press at the local newspaper the *Göttinger Tageblatt.* Half of the time in press checks was spent driving back and forth between the newspaper and Düstere Strasse.

Each night I'd call Walter Keller at Scalo to keep him in the picture and let him know if we were still on target or had fallen behind. The situation seesawed from one day to the next. Scalo wanted a good book on time for the opening in Winterthur, I wanted a perfect book – similar but not precisely the same thing. I'd been warned before I arrived that Gerhard Steidl was a man of unwavering formality and that I'd do well to respect that. I did. As did he. During the entire time working together we addressed each other as 'Herr Steidl' and 'Mr Baltz'. The guest lounge was also not what it is today. It was a plain room at the back of the printing office occupying about half of what is now the dining room. There was a filter-coffee pot, some shelves with a few *Steidl* books and a small sofa.

Looking through the books, which included *Beuys in America,* I was amazed to learn that Gerhard was a close associate of Beuys, had accompanied him to the US, and had videotaped his Dillinger performance in Chicago. He had not said a word to me about this, not a hint. When I asked Gerhard about Beuys he was very forthcoming, free and open about his work with him, both artistic and political. But not until I had asked.

I can't say what impressed me more: Gerhard's association with the most important artist of my lifetime, or his discretion about it. That was a real culture shock: in my country, and especially in the art world, discretion is rarely practised and not considered a virtue.

Each working day in Göttingen brought a new problem and a fresh solution. For the last forms we ran out of paper. We found some, in Munich; it could arrive overnight. When it was delivered we saw it was the same paper but with a matt surface. Our solution: print over the whole page. I believe it was at this point that Gerhard said to me, 'For the past three days we've been running on pure creativity.' Considering the source, I felt highly complimented – I still remember the remark after fifteen years.

It was five years before I had another chance to work with Gerhard, then three years after that, then two, then every year, and now a couple of times each year. My best moments in recent years, the moments when I least regret my choice of profession, are when I am working with Steidl. The creativity and high achievement in his atelier – for an atelier it is – are a reminder that being an artist, even trying to be an artist, is still a noble calling.

François-Marie Banier

Paris, 18 February 2009

Dear Ondine,

I have just returned from Göttingen where Martin and I spent two hectic days finishing our books. Martin's *Touched by Fire* depicts the stuffed animals ravaged by fire at Deyrolle in the Rue du Bac. My *I Missed You* – a celebration of my beloved lunatics – is the sequel to *Perdre la tête* ['losing your head'], a title that embodies how I feel when I take a photo: no longer myself, I enter the soul of my subject before whom I hold a mirror.

What an adventure working with Steidl! He leaves the layout of a book up to the artist, then leafs through it in silence, makes his comments, and disappears. The building at Düstere Strasse 4 consists of four levels. On the ground floor, the printing press runs day and night, making a monstrous din and exuding the bewitching smell of ink. Standing on their plinths, the presses remind me of a column of tanks poised for battle. On the first floor are viewers, photocopiers, printers and enlargers, which in their black sheet-metal casing look like characters from a science fiction film. On the next floor is Gerhard's office, bulging with grey plastic boxes stuffed with papers in transparent sleeves containing letters, projects and works in progress, each annotated in blue ink. He calls it 'Steidlville', this world of bristling towers worthy of *Fahrenheit 451*. Freshly printed catalogues, brochures and books accumulate atop these skyscrapers. Yesterday I discovered two folders of Japanese paper samples of every imaginable colour, each delicately hand-painted. Such refinement, imagination and traditional beauty remind me of the wonderful writings of Kawabata, Tanizaki and Dazai.

In the room adjoining Gerhard's office sit five young men and women hypnotised by their computers. One of the screens shows a series of antique picture postcards from Walker Evans's elegant collection, exhumed from its boxes by Jeff Rosenheim, curator at the Metropolitan Museum. These pictures of pale turquoise skies, yellow seas, and hotels clinging to cliffs like old widows

hunched over their walking frames – a charming, forgotten, buried vision of the world – will now be conserved for posterity. On another screen are stereo-photographs by Henry Frank, Robert Frank's father: images that retrace the history of the family. I recognise a picture of a mountain, three-quarters black and the rest white, as abstract as an August Strindberg painting. This will be the last picture in the book on Frank's work. Martin's butterflies flutter on the third screen; columns of figures flicker on the next; and on the last are the faces from *I Missed You.* Martin agrees I should add photos of two Peruvians and remove one of a top banker (although an honest one). At the top of the building are a kitchen and two rooms with large windows. Here Steidl likes to discuss a book's pictures, format and paper with the artist. An indefatigable creator, he often says, 'I have an idea for you. Let's try it.' And so we get started.

Before leaving last night I showed Gerhard some drawings and painted photos for a book. He liked them and said, 'I see two books.' We are already working on *Grandes Chaleurs,* a book about Morocco, and a series of photos of Samuel Beckett. I love the book Steidl made with Roni Horn, with almost the same photo of Hélène Cixous on every page. The man has such originality, such passion.

To you my love

Günter Grass

Behlendorf, 26 August 2009

He is difficult to catch hold of, often only with cunning, my mobile publisher. In his labyrinthine publishing house the way you meet him is upstairs downstairs. Only when I have a book to be prepared for publication and I take up residence in Göttingen, does he remain stationary for an apportioned time, advising that a drawing be moved up or to one side in relation to the text, or reduced in size to fit into the type area. When it comes to choosing the appropriate cloth for book covers or the best paper, he displays great gentleness towards materials. But once, travelling together, he appeared to me statuesque. I accompanied him to Iceland, that strange island, to which as the publisher of Halldór Laxness's oeuvre he feels a particular connection. An Icelandic publisher, who is in charge of the translations of some of my books, invited us on a tour of the island all the way to the glaciers. Steidl suffered this in silence. Having reached our destination, a hilltop with a view, I lost sight of him, for I wanted to get a quick sketch of the landscape down. Suddenly a voice sounded behind me. He was standing on a rock the size of a boulder, talking into his mobile phone. Since he spoke in short, chopped sentences, it was possible to get the gist. Via mobile he was connected with a Swedish paper mill where he placed large orders: paper of various qualities, intended for future books. Then he spoke to a bookbinder, demanding urgent delivery. This is how I saw him: high up on the boulder, glacier tips behind him, above us a chilly indifferent sky. And Steidl talking to the world. Thus he became a statue for me – quite lovable, really.

December 2008

1 December 2008

9:23 am
Lagerfeld received complete, advance copies of the Paris-Moscou presskit at the weekend and was delighted. Frank will deliver the three hundred presskits for the show tomorrow morning in Paris.

10:12 am
Polidori has returned, again, from Versailles. He sees Steidl in the stairwell and asks him how he enjoyed his recent stay in Doha (Polidori himself was there for the opening of I. M. Pei's Museum of Islamic Art on 22 November.) 'Did you like the museum?' he asks, before praising the fireworks that marked the opening – immense blooms of white, gold and silver light – as the most spectacular he has seen.

10:35 am
Marc and Matthias sort through the books that line the staircase from the typography level to the kitchen. These include Emmet Gowin's *Photographs,* Richard Serra's *Sculpture: Forty Years,* and Henri Cartier-Bresson and Walker Evans's *Photographing America 1929–1947,* stacked in little towers on the grey terrazzo stairs. They remove old titles, including some printed for Scalo.

2:37 pm
Jerry Berndt's *Insight* is being printed on the Roland 700. Andreas, operating the press this afternoon, has noticed an error on a printing sheet: he halts the machine and brings one of the affected sheets, ink still wet on its surface, to Steidl.
A low-resolution image has inadvertently been printed, creating a poor-quality, pixelated result. (*Steidl* books are designed using low-resolution, easily manageable image files, which are later substituted by high-resolution colour-corrected versions of the same images from which printing films and plates are made. When that substitution does not occur, as in this instance, the low-resolution image is printed and the result is unacceptable.)
Steidl calls Julia and Katharina to his office to address the problem. Julia is to create a new low-resolution image coupled to the already existent high-resolution one, and Katharina is to insert the new image into the layout. Once

that is done, Katharina will ask Günther Brille, pre-press, to prepare a new printing film and plate so the defective sheet can be immediately reprinted and the order of sheets is not jeopardised.

Finally, Katharina will examine the entire layout to ensure that this problem has not occurred with any other images.

2 December 2008

8:54 am

Steidl informs Elisa that the SS09 book catalogue must be finished – print-ready – today. They will discuss it with Sarah when she arrives.

11:21 am

Steidl addresses Sarah and Elisa, who are working on the catalogue at Sarah's computer: 'How long before you're finished?'

'Two minutes,' replies Sarah.

'Good.'

11:30 am

Steidl's phone rings: it is Bettina saying that Mauro D'Agati has arrived at the front desk to see him. D'Agati is a Sicilian photographer who visited Göttingen on 2 December 2007 – uninvited and unannounced – with the wish to make a book of his work. Irritated yet impressed by the unexpected visitor, Steidl had asked D'Agati to come back to Göttingen in a year's time. Today, a year to the day since his first visit, D'Agati has returned.

5:46 pm

Steidl chooses images from Juergen Teller's *Marc Jacobs Advertising 1998–2009* to be reproduced in the SS09 catalogue. One photo, an advertisement for a Marc Jacobs men's collection, shows Roni Horn posing in dark-framed glasses and holding a can of beer.

3 December 2008

12:10 pm

Julia stands precariously on a stool as she takes a photo of Steidl's fax machine from above. Her photo, along with scanned faxes to Steidl from Ed Ruscha and Lagerfeld, will accompany Steidl's text in *HE* magazine.

4 December 2008

12:54 pm
Jeff Rosenheim, curator of photographs at the Metropolitan Museum of Art in New York, has arrived to complete *Walker Evans and the Picture Postcard*, a book exploring Evans's collection of over nine thousand picture postcards, mostly from the 1900s to the 1920s, which the photographer amassed over sixty years. Jeff asks Bernard if he may work in the library at Düstere Strasse over the weekend and whether Steidl, who works on Saturdays and Sundays, would mind. Bernard says this is fine, but reminds Jeff to lock all doors behind him when alone in the office.

5 December 2008

10:08 am
Julia is seated on the tall stool at Steidl's desk with her phone to her ear. Steidl, currently on a plane to Los Angeles, has called Julia and asked her to look for certain documents on his desk: she sifts through assorted papers and begins to read to him from a list of the various paper stocks in storage in Göttingen.

12:21 pm
Steidl calls me from the plane, announcing himself ironically as 'Air Force One'. He asks me to check with Al-Thani if 19 December is convenient for his next visit to Doha.

12:54 pm
Inès Schumann, pre-press, and Polidori stand at the light table outside the digital darkroom, examining colour corrections Inès has just made to a Versailles photo. Two colour proofs hang before them: one showing the photo before her adjustments, the other showing it after them. Polidori compares the two images and asks Inès if the image could be made slightly less yellow.

1:29 pm
For his current stay in Göttingen, Polidori has set up office not in the library as in the past, but in the digital darkroom on the image-editing level. (This room – painted black with a camera on a tripod against one wall – is not a darkroom for developing photos, but a studio where artworks too fragile to be scanned such as drawings and antique books are digitally photographed.)

In a corner of the darkroom, a large wooden panel laid across two grey transport crates forms Polidori's temporary desk. Today he is working on 'Upon Closer Scrutiny', volume three of *Parcours Muséologique Revisité,* which comprises photos of details of paintings housed at Versailles.

Polidori determines the sequence of images in the book by cutting out photocopies of the photos and gluing them onto fresh sheets of A3 paper, each representing a page in the book (Jonas will in turn lay out the book on computer using Polidori's collages as a template.) Hundreds of snips of white paper, the result of Polidori's frenetic scissoring, coat the floor at his feet. He declares, with a mix of humour and conviction, that he prefers his new office to the library, because although he is a self-declared 'social animal', he finds there is too much pressure to socialise there.

Polidori's girlfriend, the painter Brittany Sanders, sits at another makeshift desk in the darkroom, sifting through books on the paintings at Versailles, searching for the titles of those reproduced in *Parcours Muséologique Revisité.* On a small table to her left, Brittany has laid out a simple indoor picnic of cheese, fruit and bread (she has a particular weakness for *Laugenbrötchen*), which she offers to those who enter the darkroom.

2:12 pm

Reiner Motz, pre-press, stands at the light table sorting proofs. As he moves his hands, the small green tattoo of a butterfly on his right forearm seems to flutter.

2:56 pm

Jeff is seated next to Sarah; together they refine a section of the *Picture Postcard* book containing an essay by Jeff interspersed with illustrative postcards. He laments his inability to use a computer to design in this way, as he finds marrying text with corresponding images the most rewarding aspect of book-making.

3:44 pm

Claudia leads a group of students on a tour through Düstere Strasse 4. The punkish teenagers follow her in a tight, cautious line.

8 December 2008

9:04 am

Steidl enters the typography level, having returned from Los Angeles. 'Welcome home!' bellows Jeff.

9:14 am

François-Marie Banier and Martin d'Orgeval have arrived and greet Steidl with two-cheek kisses. 'So then,' says Steidl, 'we start with our work?'

The three men discuss Martin's *Touched by Fire,* containing his photos of the charred remains of Deyrolle, the taxidermy and entomology shop in Paris's Rue du Bac that was gutted by fire in the early morning of 1 February 2008. The photos – depicting the aftermath of the fire including singed butterfly wings, burnt beetles, and a disfigured stuffed zebra – occupy the right-hand pages. On the left-hand pages is a dense list of the 33,000 species of butterflies known to man.

10:11 am

Polidori asks Steidl how he is feeling after the flight from Los Angeles. 'Good, good,' comes the reply.

12:17 pm

Steidl asks Sarah restlessly whether the book catalogue is print-ready.

3:27 pm

Elisa shows Jeff and Polidori the pages representing their respective publications in the book catalogue. Both have corrections: Jeff notices that two postcards have been cropped, while Polidori is unhappy with the photos on the covers of the volumes of *Parcours Muséologique Revisité.* Sarah incorporates Polidori's changes and gives him a print-out to approve. He does so quickly, signing his name on the page with a flourish, before rushing into Steidl's office and dropping to his knees before him: 'Don't be angry with me!' Polidori apologises with a mix of theatricality and earnestness for the late corrections, but promises they are worth the trouble.

5:29 pm

Lagerfeld's photos for the Chanel Spring-Summer 2009 accessories campaign have arrived. Inspired by Colette's *Chéri,* the black-and-white images depict Jerry Hall languidly reclining on a satin-covered bed with her young lover played by Baptiste Giabiconi. Glittering jewels adorn Hall while faux Chanel shopping bags – calfskin replicas of paper shopping bags, complete with carry-cords and 'Chanel, 31, Rue Cambon' printed on their sides – lie on the bed.

9 December 2008

9:47 am

Lagerfeld has faxed Steidl a handwritten text for the SS09 catalogue that will introduce the books to be published this season by his imprint Edition 7L. Jan types up the text, before Sarah inserts it into the layout and gives Steidl an A4 print-out to fax Lagerfeld for approval. In the text, Lagerfeld likens the experience of digesting books to the image that opens Arnold Schoenberg's *Pierrot Lunaire:* 'The wine which through the eyes we drink'.

11:48 am

Banier saunters into the typography level in dandyish apparel: lilac trousers, houndstooth jacket, trilby hat, red scarf and Leica camera around his neck.

2:06 pm

Banier and Martin are working on *Touched by Fire* with Katharina, when Julia enters the room. Banier swivels on his chair and greets her with the cry, *'Bonjour ma chérie!'* Julia laughs.

4:06 pm

Steidl is rummaging through overlapping piles of paper on his desk. His cordless phone rings: it is Herr Zillmann from Lachenmaier. 'Hallo, just a second!' spurts Steidl, before dropping the phone on the table and continuing to search among his papers. A good minute later, Steidl leans over the phone without picking it up (it floats, face up among the papers) and cries, 'Hang in there, Herr Zillmann!'

8:11 pm

Steidl, Banier and Martin huddle around my computer screen to watch *Coco 1913 / Chanel 1923.*

10 December 2008

9:03 am

Steidl: 'I hate working for advertising agencies – they make me sick.'

11 December 2008

12:17 pm

Steidl is in New York for the Steidl Artists' Party. Polidori pokes his head around the steel door into the typography level: 'It's a reduced crew today.'

12 December 2008

12:00 pm

Steidl complains to Claudia that the German literature catalogue is behind schedule because Jan was not in the office on Monday. Claudia says that actually Jan was in the office on Monday. Steidl repeats that he was *not* in the office, and that he has an explanatory note from Jan as proof. Claudia, adamant yet polite, reaffirms her position. Agitated, Steidl calls Jan for clarification – Jan confirms he was indeed in the office on Monday. He says that the texts for the German catalogue are approved, copy-edited and ready to be inserted into the layout.

5:44 pm

Melanie cheekily tells Polidori she is sorry to have missed seeing him kneel before Steidl and apologise for making changes in the catalogue. Polidori, un-miffed and somewhat proud, replies, 'I'm an unashamed whore, I'm prepared to do what it takes.'

15 December 2008

8:47 am

Günter Grass is on his way to Göttingen. Sarah has arrived in the office early to prepare *Unterwegs von Deutschland nach Deutschland* for his visit.

10:53 am

Eric and Steidl discuss the Chanel SS09 advertising catalogue. It will consist of two items packaged together: *Sunlight in Vermont,* a softcover book of Lagerfeld's photos taken in Vermont; and a thinner stapled brochure on a different paper stock of his photos of Jerry Hall.

11:33 am

Jeff is engrossed by corrections for the *Picture Postcard* book: Steidl wants to start running films and printing plates by noon.
'Are you happy, Jeff?' asks Bernard, who has been designing the book with him.
'I'm nervous, and I'm making Katharina crazy.'
Jeff says with an ironic smile that it would be nice to be able to leave Göttingen at some point this year.

12:16 pm

Grass has arrived. Surprisingly short, with a kind face, a full head of brown hair

and a thick moustache, he enters the typography level with Frank, who drove him from Lübeck to Göttingen this morning. Steidl, seated at Sarah's computer screen, swivels on his chair and greets Grass with a hug. There are twenty-three years between the two men. Grass offers each person in the room a handshake and a warm smile: Sarah, Jeff, Bernard and myself. Hans Grunert, Grass's stepson, also introduces himself.

3:33 pm

Grass is seated next to Sarah, and leafs through potential illustrations for *Unterwegs von Deutschland nach Deutschland,* his pen drawings of symbolic motifs including fish, crabs, mushrooms and beetles.

Grass wears a white-and-brown striped shirt, a chestnut-brown woollen jumper and a chocolate-brown corduroy jacket. His trousers are of yellow-brown corduroy, and his leather shoes have black soles. He smells of tobacco. His pipe, lying on the table before him, is of speckled wood and has a chipped bowl.

Grass sifts through print-outs of the drawings, searching for a motif for the dust jacket. He settles on a grasshopper, a symbol of West Germany's aggressive exploitation of East German industry and infrastructure following reunification – like a swarm of grasshoppers devastating a field of grain. As Sarah positions the grasshopper on her computer screen, Grass hunches forward to study the insect through his dark oval glasses. Steidl watches over Grass's shoulder and says, 'Not bad, not bad.'

'Better, no?' says Grass.

'Better,' replies Steidl, as he positions himself between Sarah and Grass. The grasshopper will appear twice on the dust jacket, once facing left, once facing right. They test two fonts, Antiqua and Akzidenz, for the typography of Grass's name and the book's title on the dust jacket. The more ornamental and less clinical Antiqua is chosen, as it is more appropriate for a book that combines subjective recollections to form a descriptive narrative.

Grass opens a large box of matches and places his pipe in his mouth. He lights a match, inserts its flaming head into the pipe, and inhales. His right thumbnail, discoloured by years of tobacco smoke, is a pale brown crescent.

5:43 pm

I ask Grass about an episode from *Peeling the Onion* that had fascinated me, his

unannounced visit to Giorgio Morandi's studio with his first wife Anna in the late summer of 1954. Grass's eyes twinkle at the memory and he recalls Morandi's two sisters, clad in black, with whom the artist lived in Bologna; the blank canvases lining the studio that were pre-sold to American buyers; and the actual vases, jugs and bottles from Morandi's paintings lying dust-covered on a veranda.

6:18 pm
Unterwegs is not print-ready. Grass must return to Göttingen at the beginning of January.

16 December 2008

1:01 pm
Steidl calls Jeff down from the library and jokingly tells him he is fired. More earnestly, he explains they must plan a work schedule together this afternoon: 'If I don't do my programme, then my day is fucked.'

17 December 2008

3:31 pm
Steidl playfully tells Jeff that if he were ever to lose his job at the Met, then he would be welcome to work as a designer for him. Reflecting on the inordinate length of his stay in Göttingen, Jeff replies with a laugh, 'Well yes, I *may* lose my job.'

3:55 pm
Lagerfeld has sent corrections for *Sunlight in Vermont:* he has rearranged the colour photos and inserted new black-and-white images, which will be sent to Göttingen to be scanned.

18 December 2008

9:23 am
Steidl is at Frankfurt airport, waiting to depart to Doha.

11:27 am
A rigid cardboard box, 50.8 cm wide and 61 cm high, leans against the wall in the stairwell outside the digital darkroom. Originally containing Ilford photographic paper, Lagerfeld has used the box to send the black-and-white prints for

Sunlight in Vermont to Göttingen: the words *'Urgent / Pour Mon. Gerhard Steidl / M. Frank vient chercher dimanche'* adorn it in his arabesque red handwriting.

3:10 pm
Achim Grohs and Achim Paul, scan operators, check that all the *Sunlight in Vermont* prints have been scanned.

19 December 2008

9:42 am
The final correction for *Sunlight in Vermont* – that the cropping of a photo of Heidi Mount standing in a doorframe be altered – has been made. The catalogue is print-ready.

5:46 pm
Klaus Staeck, who will visit Göttingen tomorrow and stay until Sunday, calls to see if there is a guest apartment at Düstere Strasse 5 free tomorrow night. All rooms are occupied, says Hilda, who today is wearing a T-shirt with 'Spirit' spelt out on it in gold sequins: Polidori and Brittany are in the Grass apartment, Mona Kuhn is in the Dine apartment, and Jeff is in the Beuys apartment. Staeck says that Gebhard's Hotel at Goetheallee 22–23 is booked out. I suggest Hotel Eden at Reinhäuser Landstrasse 22 a.

22 December 2008

10:56 am
Polidori leaves Göttingen today, although *Parcours Muséologique Revisité* is not yet complete. Over the weekend he cleared out the digital darkroom, which now appears orderly, empty and lifeless. Polidori and Brittany are to depart for a spa in Baden-Baden, where they will spend Christmas. (Polidori, an avid bather, laments the lack of bathtubs in the *Steidl* guest apartments.)

10:58 am
Polidori bursts onto the typography level, his legs swinging as if hinged to his torso. He bids goodbye to all with handshakes and kisses on cheeks. I tell him to enjoy his bath: 'I will, I need it,' he says, before disappearing into the stairwell.

William Eggleston

Memphis, 27 August 2009

Maybe – no, *certainly* we should be thankful there is only one Gerhard on this planet. For there is certainly not room for two. Or, could a vacation villa be arranged for him on Jupiter – in the red spot of course. But he just might take with him so many Steidl books, which I'm sure they could use – plenty of room I am told.

Fazal Sheikh

Zurich, 24 June 2009

Although nearly fourteen years ago, the memory of my first visit to Gerhard's halls of splendours and tortures in Göttingen remains vividly etched on my memory. It also happened to be the first occasion on which I made a book. Stepping across the threshold and walking through the maze of doors and stairwells by the printing press, I had the immediate sensation that this was a place in which, given the invitation and opportunity, I could feel at home; a place with a pace and creative dynamism that was intoxicating.

That first night, while I was still reeling from jetlag, Gerhard invited me to join him for dinner out in the town. As we walked through the darkening streets, we were joined along the route by various friends of his, so by the time we reached the restaurant we had become a small group. Squeezing through the entry into the warm room, one of them whispered to me that tonight was a celebration of Gerhard's birthday. We were greeted by the hostess and seated around a table with the waitress ranging over the daily specials while sprinkling her talk with jokes hurled in Gerhard's direction. Looking at these faces perched

around the table, one could easily imagine them years earlier clustered together somewhere in the parks of the town as teenagers, joking and conspiring with one another.

When it was time for dessert, one of the friends slipped away from the table, returning several minutes later to sneak up behind Gerhard with a present. Now, it should be noted that anyone who has visited Steidlville is familiar with the signature sterile dental coats that Gerhard wears over his street clothes every moment when he is at the publishing house. The visitor encountering Gerhard for the first time wrapped in one of these coats – the only thing visible beneath it a swatch of jeans and sneakers, and with his dishevelled spike of hair – might well wonder if perhaps he or she hadn't stumbled into the wrong office and were meeting the local skateboarding dentist, rather than the owner of a publishing house.

As the box was laid in front of a surprised Gerhard, he removed the lid to find one of the dental coats lying within. This particular birthday coat, however, was not the immaculate white of the everyday, but rather one which had been sent to the artist A. R. Penck, for whom Gerhard had made screen-prints and stone lithographs in years prior. Penck had made a piece of art out of the coat – emblazoning it with his signature red and black sweeps of brushstrokes and figures. As he stood to model the coat, an impish look of delight came over Gerhard's face. Later that night, as we made our way back along the streets, I couldn't help but notice how tightly he was clutching the box. In the years since that evening, each time I arrive at Steidlville I half expect him to bustle into the room, arms akimbo, laden down with his usual bundle of books and paperwork, wearing that unique Penck coat from the first night we met. But each time I am disappointed.

It is common knowledge that no one has ever seen Gerhard sleeping and that he can be found rampaging through the corridors of the house at all hours of the day and night. One night, towards dawn during a recent visit, I was working and happened to pass Gerhard's office. There, in the darkened room, I could make out his dental coat draped over the back of the chair, patiently awaiting its master's return. It was then that I wondered if perhaps there were a few minutes each night, the rest of the town already deep asleep, when Gerhard slips out of the publishing house and heads home, stepping through

the entry where he is greeted by the Penck coat hanging faithfully beside the door. Gerhard wraps the coat around himself, slips into bed, and is instantly swept by sleep toward artistic dreams of further publishing empires to conquer and groundbreaking new techniques with which to produce the most sumptuous books. Waking completely refreshed, he removes the coat and saunters back to the publishing house. In the muted pre-dawn light, he slips on his blank white dentist's coat like some sort of tabula rasa costume, ready to receive the new artistic encounters of the day.

Now, many years and collaborations later, I am often confronted with the unique and special gift this character has been in my life, and the impact his teaching and friendship have had on my work. Gerhard would certainly acknowledge that I have not always been the most docile guest, fretting as one will over that about which one cares a great deal; bringing an idea which the mind has ranged over for years – simmering and transforming itself over time – to life. This is no easy endeavour, and one that causes great concern when so much is at stake. In the passing years, my mania has been softened by immersion into the Steidlville family where Maestro Gerhard is always there to help consider the next step and how to bring a piece to fruition. For me, as for many artists, there is no one better suited to offer the gift of advice and commitment to making our visions, our dreams, come true. For this simple fact, for the generosity of his counsel and friendship, I am enormously grateful. May he sacrifice more of his sleeping hours to bring these books to life (I recently reminded him that Gandhi and Churchill were able to subsist on less than three hours per night and if he would simply meet their standard, he could certainly eke out a few more publications a year). If he won't do it, I don't know who could.

January 2009

5 January 2009

9:04 am

Today is the first working day for *Steidl* in 2009. Steidl himself has a cold and is unshaven, but is otherwise in good spirits.

10:41 am

Eric and Steidl discuss the invitation for the Chanel Haute Couture Spring-Summer 2009 fashion show. The show will take place on 27 January in the Pavillon Cambon-Capucines, a former bank at 46 Rue Cambon, a stroll from Chanel's headquarters. Lagerfeld has an idea for the set decoration but must first discuss it with his construction team. If feasible, then the design of the invitation will mirror the aesthetics of the set.

10:59 am

Roni Horn has returned to Göttingen to print *Roni Horn aka Roni Horn*. She sits in the library, sketching the plans for her exhibition at Tate Modern.

11:28 am

Koto Bolofo has arrived to work on the eleven-volume *La Maison*, a photo-documentation of the workshops of Hermès. Koto wears thick, black, 1950s-style glasses that slip down his nose.

11:57 am

Eric explains to Steidl Lagerfeld's concept for the haute couture invitation: simple and white, it will feature a flower or floral ornament cut out of the paper.

12:27 pm

Jan has given Sarah text corrections for *Unterwegs von Deutschland nach Deutschland*. He kneels beside her computer, searching the screen for peculiar accents to be inserted into certain words, not least important for Grass's birthplace Gdańsk.

2:14 pm

Steidl reminds Sarah that the design of *Unterwegs* must be finished by tonight as Grass returns to Göttingen tomorrow to approve the book for printing. She says she is working as fast as possible. Steidl suggests the task be split if it is too

much: that Katharina inserts Jan's text corrections while Sarah simultaneously finalises the book's typography and layout. Sarah thinks this unwise, because as the text corrections are inserted, the book's illustrations may shift to incorrect positions in the text that only Grass himself can discern and amend.

6 January 2009

9:02 am

Steidl is irritated because three of the varnishing forms, the layers of transparent lacquer printed over the images in a book, in *Roni Horn aka Roni Horn* are the wrong size. He has halted printing until the forms are corrected and new printing plates made. The plates for the entire book must be checked to ensure the problem is not present elsewhere.

12:02 pm

Grass arrives, again dressed in brown. He heads to the kitchen for a double espresso. Frank carries Grass's bag for him. The large box-like bag is of creased, brown leather, and its stitching is frayed. Brass rings secure a thick leather handle to the top of the bag, and several zippers run its length. As Frank places it on the grey granite bench top, the bag sags at its corners, as if exhaling after a long journey.

12:21 pm

Grass enters the typography level and Steidl welcomes him with the words 'Happy New Year!' Although a little taken aback by Steidl's English greeting, Grass shakes his hand and hugs him. He teases Steidl about having gained a tan over the Christmas break. This Steidl denies with a laugh, saying he was only outside for one day during the holidays.

12:34 pm

Steidl plans the day's schedule with Grass, who will return to Lübeck this evening. *Unterwegs von Deutschland nach Deutschland* must be approved for printing by then: paper and linen for its production lie ready. Steidl asks Grass and Sarah first to finalise the page count so that the number of sheets required to print the book can be calculated. When this is done, typographic fine-tuning including spacing, paragraphing, and the definitive placement of illustrations within the text can be completed.

12:53 pm

Grass takes a seat next to Sarah and work begins. He sips from a small glass of apple juice. After a few minutes he removes a grubby white pipe cleaner from his inner coat pocket to prepare his pipe for fresh tobacco.

4:27 pm

The mayor of Göttingen, Wolfgang Meyer, has arrived to meet Grass.

5:18 pm

The design of *Unterwegs* is complete. Steidl asks Sarah to print out its pages at reduced size on A3 paper, so he can gain an overview of the book's flow and structure. Grass asks Steidl what his feeling towards the layout is: 'good' is the response, there are only a few slight details he would like to review. The three huddle around Sarah's computer and examine the book together for the last time.

6:03 pm

Both Grass and Steidl have signed off on *Unterwegs von Deutschland nach Deutschland,* and are pleased. Printing plates will be made tomorrow morning.

7 January 2009

9:09 am

Steidl is ill but nevertheless at work: his raw coughing echoes throughout the stairwell.

11:10 am

Banier and Martin have returned to Düstere Strasse 4.

11:14 am

Koto, who has been working on the layout of *La Maison* on the dining room table, will move to the digital darkroom where there is more space for him. Koto collects the small colour print-outs he had spread across the table, each depicting a photo from 'Kelly Bag', the volume of *La Maison* that explores the production of Hermès's Kelly handbag. Koto explains that each bag is produced by a single craftsperson and bears his or her initials.

11:57 am

Sophie calls Steidl with an update on the haute couture invitation: Lagerfeld will either draw or photograph a posy of paper flowers. She asks that 1,500

envelopes be sent to her attention today so that calligraphers can begin inscribing the guests' names on them.

1:47 pm

Banier is restless: he wanders around the typography level, glancing at open books and trays of materials, searching for something of interest. Suddenly, he thrusts his arm into an open cardboard box lying on the floor, removes a handful of shredded paper and stuffs it under his trilby hat, so the shreds hang over his ears like a clown's wig. For the rest of the day Banier proudly wears his costume, even when crossing snow-covered Düstere Strasse to visit the bookbinder Oschmann.

8 January 2009

9:20 am

Koto is working under the bright fluorescent lights of the digital darkroom. He holds several square colour print-outs in his hand, each showing one of the photos taken in the Hermès workshops. He determines the sequence of images in each book by laying out the print-outs in rows on a large wooden table: a single image occupies page one, followed by pairs of images for the subsequent double pages.

Koto is currently working on 'Special Orders', the volume of *La Maison* documenting the peculiar commissions that Hermès receives. He recounts with wonder the little packages of gold leaf used for embossing leather in the workshops, leaves so fine that they fall like feathers through the air.

9 January 2009

9:27 am

Lagerfeld's photo of white paper flowers for the haute couture invitation has arrived. Judith prepares PDFs of the design for the invitation, presskit folder and badge to email to Chanel for approval. On the front of these items sits the delicate posy: a circular layering of pale petals, leaves and blossoms.

12:22 pm

David Bailey calls me. I ask how he is: 'Well, I'm still alive,' comes the reply. In his gruff but warm tone he asks how the 'fuckin' scarlet pumpernickel' is, meaning Steidl. He asks for a PDF of *Eye,* an upcoming book of his portraits,

to be sent to Tony Shafrazi who will write the introduction. *Eye* includes photos of sitters such as Francis Bacon, Henri Cartier-Bresson, Jean Shrimpton and Jean-Luc Godard.

4:11 pm
Steidl chooses the endpapers for *Unterwegs von Deutschland nach Deutschland:* cursive handwritten pages dotted with drawings from Grass's 1990 diary.

4:14 pm
Steidl has made test-prints of the haute couture invitation on two different kinds of paper. He will send two sets of the samples to Paris today: one to Lagerfeld and one to Eric. Steidl hopes to have Lagerfeld's choice by tomorrow so he can print the invitations on Monday 12 January.

4:20 pm
Roni takes photos of Steidl in his office with a disposable camera, images to be shown in the 'Lasting Impressions' exhibition. 'I wanna get you from behind!' she cries, 'You're one of the few people who's recognisable from behind!' She snaps, winds the camera, and snaps again: 'I like this camera, it's got feedback baby! It's just like an iPod.'

12 January 2009

9:37 am
Lagerfeld has sent corrections for the haute couture invitation: the posy should be darkened minimally, and made more defined. He has chosen the Plike paper, with its smooth plastic-like texture and cool white hue, over the rougher and creamier Arches paper. 'I have prepared everything and we just start now,' says Steidl to Sophie on the phone. The invitations will be delivered on Wednesday 14 January and the badges by the end of the week.

13 January 2009

5:16 pm
Michael Mack and Paul Graham have arrived to finish designing and to print the German and English versions of *Paul Graham,* a book to be released for Graham's exhibitions at the Museum Folkwang in Essen from 24 January to 5 April 2009, and at the Museum of Modern Art in New York from 4 February to

18 May 2009. Steidl asks Michael when the German version will be print-ready: 'tomorrow lunchtime' is the reply.

14 January 2009

11:48 am

Michael and Paul rush to complete the German version of the book: translating the English texts has been more complicated than expected.

15 January 2009

9:46 am

Paul asks Steidl if he will use regular or high-density black when printing the book. Steidl answers with a grin: 'We never use regular black, we don't even have regular black.'

16 January 2009

9:27 am

Paul is standing by the photocopier outside Steidl's office examining potential binding materials for his book. He has been told that cloth is too expensive and the book must be bound in paper. Paul leafs through samples of reflective papers with a cloth-like quality. He likes a mauve paper but decides on a dark blue one, on which 'Paul Graham' will be embossed in light blue for the front cover. Paul explains that blue is a theme throughout the book: titles and other typographic details are printed in the colour.

9:38 am

Steidl tells Paul that the book can indeed be cloth-bound as a supplier has just confirmed an acceptable price.

9:54 am

Graham asks Steidl if it is possible to have a handful of English versions of the book delivered next week to the press department at the Museum of Modern Art. Steidl replies no, as it will take two and a half days to make printing films and plates for the book.

5:01 pm

Steidl clears out the various rubbish bins on the typography level, tipping the contents of one into another. In doing so, several scraps of paper fall onto the

floor. As he kneels down to collect them, the horizontal fabric strap at the base of his lab coat pulls tight.

19 January 2009

1:38 pm

Winston Eggleston, William Eggleston's son and managing director of the Eggleston Artistic Trust, has arrived to print his father's *Democratic Camera: Photographs and Video, 1961–2008,* for an exhibition at the Haus der Kunst in Munich from 20 February to 17 May 2009. Steidl says to Winston with a smile, 'When you are a little more experienced, you should start to think in CMYK.'

4:03 pm

Lagerfeld would like the material for the haute couture presskit to match the paper that will cover the tables for the guests at the fashion show. Steidl will take different paper samples to the presskit shoot in Paris tomorrow and compare them with the paper tablecloths.

20 January 2009

1:37 pm

Banier calls Elisa and sends kisses to all at *Steidl.*

21 January 2009

9:15 am

There is a problem with the foil embossing on the cover of *Paul Graham*, copies of which must be in Essen for the exhibition opening on 23 January. The bookbindery Buchwerk in Darmstadt, responsible for the embossing, has been unable to contact Steidl this morning – he is currently asleep in the car, returning to Göttingen with Frank from the presskit shoot – and has called Bernard instead. Bernard calls Frank, who wakes Steidl. Bernard explains that the magenta foil for the embossing does not hold well on the cloth: the bindery can nevertheless complete production but it would take two months. Steidl asks that Buchwerk call him directly on his mobile.

9:33 am

Katharina has finished designing the invitation to Grass's premier reading from *Unterwegs von Deutschland nach Deutschland,* to take place at Göttingen's Georg-August University on 6 February.

10:17 am

Steidl and Frank arrive. Frank takes the DVD containing the photos from the presskit shoot directly to Judith, so the images can be prepared for printing this afternoon. Steidl enters the typography level in black jeans and a T-shirt, scratching his head.

11:10 am

Sophie calls to discuss the haute couture presskit with Steidl, who is on the phone with Paul Graham. He and Paul decide to use an unproblematic silver foil embossing instead of magenta for the cover of the book.

11:12 am

Sophie asks Steidl about the order of the presskit photos. He confirms that the title sheet – showing a wreath of paper flowers against a black background and the name of the collection – will appear first in the presskit, followed by seven photos of Freja Beha Erichsen modelling the collection.

22 January 2009

9:24 am

The haute couture presskit photos have been printed and lacquered, and are ready to be assembled into the folders. Steidl asks me to prepare two sample presskits with the photos numbered in the correct order: one will be sent to the bookbinder Walter in Göttingen who will assemble the presskits, the other will remain with Steidl for reference.

5:15 pm

Steidl complains of the excess of emails he receives daily: 'I waste my whole day on this shit.'

26 January 2009

12:41 am

Steidl is on the phone to Grass, talking about book projects beyond *Unterwegs von Deutschland nach Deutschland*.

6:17 pm

Steidl has departed for Frankfurt, from where he will fly to Paris for the Chanel haute couture show tomorrow morning.

27 January 2009

7:38 am

Paris. Steidl emerges from the Hotel Castille where he has spent the night, crosses Rue Cambon, walks past employees of the Hotel Ritz smoking outside its back entrance, and enters the Pavillon Cambon-Capucines where the Chanel show is due to commence at 10:00 am.

7:46 am

Steidl descends a staircase to the backstage area, a large, low-ceilinged room. Here are tables laden with objects spread out like still-life compositions. A long table lines one wall, covered by food and drink including little glass jars of yogurt, a pyramid of espresso cups, circular portions of butter individually wrapped in gold foil, bread rolls, assorted fruit, and pastries dusted with icing sugar. Models and members of the hair and make-up crews wander to and from the table.

Along another wall are the make-up tables, each with a mirror framed by light bulbs. Here sit rows of nail polish bottles, open tubs of beige powder, eyelash curlers, black make-up brushes, and jars of cotton buds. Hairdryers, gold cans of hairspray, brushes, combs, and scatterings of bobby pins lie on the hair-dressing tables.

On a table in the centre of the room are the delicate headdresses that the models will wear during the show. Each headdress is a handcrafted paper sculpture (mostly white, some black), depicting a different flower or plant. There are roses, hydrangeas, stalks with fanned leaves, vines, tendrils, bunches of grapes, and even a ripe ear of corn bursting from its husk. Here stands the chief hair-stylist Kamo, a composed, bespectacled Japanese man in a buttoned white shirt, surrounded by clusters of attentive assistants.

8:17 am

Steidl wanders upstairs to the hall where the show will take place, looking for Eric. On the way he bumps into Sophie, who wears a headset and a concentrated expression, and greets her with a kiss on each cheek. Steidl enters the hall, a grand room with a lofty ceiling and flanked by marble columns. White paper decorations adorn the room, including four-and-a-half-metre-tall paper garlands of flowers larger than dinner plates that line the columns, and hanging electric

lanterns in the form of paper discs. Through the room weaves a black U-shaped runway surrounded by circular tables with white tablecloths and vases of paper flowers in their centres. Awaiting each guest on his or her chair is a presskit.

9:45 am

Amanda Harlech rushes down the staircase, headed backstage. A guard stops her at the entrance and asks to see her badge, which she has mislaid. 'I know, I know,' she exclaims, 'but I *promise* I work for them!' The guard yields and she sails past him.

10:24 am

The guests have taken their places and wait for the show to begin. Some open their presskits and leaf through the photos.

10:26 am

The show begins. Steidl watches from behind the ornate cast-iron balcony of the high gallery that lines three walls of the hall. Lagerfeld, hidden from the audience's sight, observes from a corner of the same gallery; Harlech and Virginie Viard, director of the Chanel studio, whisper in his ear.

The collection has been inspired by paper – by its whiteness, purity and the imaginative potential held within it. Square-shouldered jackets with high circular collars, bodices of fabric flowers and long feather-covered skirts present a spectrum of whites: snow-white, off-white, cream-white, white edged with black. The paper headdresses quiver as the models descend a staircase at one end of the hall and navigate the runway. The show's finale is a wedding gown worn by Erichsen, her head encapsulated by an enormous paper rose whose overlapping petals encircle her face.

10:45 am

The show concludes and Lagerfeld makes his lap of the runway. After the applause has faded and the guests have trickled outside, Steidl, still standing in the gallery, scans the hall below him.

He sees that not one presskit has been left behind; each has found a new owner. He smiles, takes a small pad of paper from his jacket pocket, and makes a note of something he does not want to forget.

Joel Sternfeld

New York, 24 June 2009

When I think of my publishing history with Steidl, one book in particular always comes to mind. It's the small one entitled *Walking the High Line* that first appeared in December 2001, less than three months after the September 11 attacks. The World Trade Center was destroyed, downtown Manhattan bore aspects of a war zone and people in the subway were silent as they sat with a thousand-yard stare in their eyes.

In those fraught days, on 15 October to be precise, I turned to Steidl with an urgent request to make a book quickly. For the previous year and a half I had been photographing an abandoned elevated railway that runs down the west side of Manhattan. It was a ruin seeded with wildflowers carried by the freight trains that had rolled down its rails twenty years before. Unbeknownst to millions of New Yorkers, true seasons occurred up there above the streets: a springtime that made me think of an alpine meadow, a summer like a river of grass, an autumn that resembled the wheat fields of Canada. Now it was being threatened with destruction by property interests wanting to develop the land beneath it.

In early October we, the Friends of the High Line, learned that the forces opposing preservation were using the chaos of the period to press forward negotiations for demolition. And so I turned to Steidl – I felt that if there were a book making the wonders of the seasons on the High Line accessible to others it might help save this secret garden.

Steidl agreed (in a 'Steidl minute') and he and I designed the book on the spot. A few weeks later I went to Göttingen and the book was produced. I also scheduled an exhibition of the work at PaceWildenstein in Chelsea for early December. Steidl promised there would be books at the opening on 4 December. Each day in late November and early December I checked with the gallery to see if they had arrived and each day I got a negative response. Finally, on 3 December, the night before the opening, I called Gerhard. He picked up the phone at 4:30 in the morning – his day was starting. I simply, and I hoped calmly,

informed him that the books had not arrived. He was surprised and promised to look into it – as soon as Federal Express in Frankfurt opened at 7:00 am.

As it turned out, the books had been sitting on a pallet at FedEx for four days – the dimensions of the shipping container exceeded the allowable limit but no one had bothered to inform Steidl. And so that morning Gerhard hired a courier who filled two suitcases with books and got on the next Lufthansa flight to New York. Legend has it that Steidl called the then German chancellor Schröder to have the flight delayed so the courier could catch it. Whether that is true or not I can't say, but I do know that there were books in the gallery when I walked in at 5:00 pm.

All of the stars had to align for the High Line to be saved – and they did. The little book was one of those stars. Two weeks ago the first section of the park opened to the public. The architects Diller Scofidio + Renfro and the landscape designers James Corner Field Operations have made something that simultaneously feels completely new and at the same time remarkably like the landscape that was there ten years ago when I walked it alone.

The little book that Steidl made and couriered to New York was pivotal to the fate of the High Line. At the time I made my request to Steidl to publish a book in a hurry, I didn't know Gerhard all that well. But I told him that it was important. And Steidl did what I now know he always does: he turned out an impeccably printed, slightly mass-produced artist's book. And, just like always, before the first sheets were finished coming off the press he was onto the next book.

Roni Horn
New York, 17 December 2008

One of the signature details of Gerhard's style is his habit of clearing his throat on approach and departure. As a form of greeting: it usually occurs well in advance of his arrival – from around the corner or from another room, for example – preparing me for impact. As a form of departure: I hear it out the window and from down the road as the goodbye of someone who never really leaves.

Artistic Circles

Jim Dine and Diana Michener

Göttingen, 8 December 2008

Jim Dine, seventy-three, and Diana Michener, sixty-eight, have just returned from the gym, which they visit together daily. They are seated at a rectangular coffee table covered by clutter in their Göttingen apartment. Dine sips vodka from a martini glass, while Michener nurses a glass of red wine poured from a fire-engine-red ceramic jug sitting on the table.

Facing Nikolaistrasse and once a bicycle shop, the apartment is a long white room with a kitchen, bedroom and bathroom attached. The main room is simultaneously Dine's studio (colourful canvases depicting hearts and bathrobes lean against one wall), a living room (the cluttered coffee table), and an office of sorts for Michener (a typewriter jostles for space on a crowded trestle table at one end of the room). Terracotta pots brimming with rosemary and basil sit outside the kitchen door, which opens onto the parking lot at the back of Düstere Strasse 4. To walk from Dine and Michener's kitchen to the Roland 700 printing press takes less than a minute; to climb the stairs to Steidl's office takes just over two.

Michener is tall and bird-like, and her long brown hair, streaked with grey, is clipped at the back of her head. Tonight she is wearing a baggy flannel shirt over a white T-shirt. Her glasses have brown-tinted lenses, and a green-and-white handkerchief occupies her chest pocket. Dine, shorter than his wife and stocky, wears black suede New Balance running shoes, a navy long-sleeved shirt and frameless glasses. He takes walnuts from a large ceramic bowl on the table before him, breaks them with his hands, and eats the kernels. On the table also sit several books including Dine's *Some Drawings* and volumes on Classical Greek sculpture and Édouard Manet, a shabby Filofax, a green glass vase of little daffodils, and the red jug from which Dine has now poured wine into his emptied martini glass.

The details of Dine and Michener's first meeting with Steidl are not immediately clear in their minds. Their shared history with him reveals itself in overlapping pieces and bursts of enthusiasm.

Diana Michener: The first encounter was quite amazing, very moving. We were living in the Hotel de Suède in Paris.

Gerhard walked into the lobby and said he wanted to make the book *Birds* with Jim, that he was ready. He was so touching and gentle, I was very struck by that. Remember, we were sitting in the corner at a little round table?

Jim Dine: Yes – he came to Paris for that, then he came to New York to pick up printing plates for *Birds*. Ruthie and Julia had things ready for him. That was when Gerhard *set up office* at Pace Editions – Ruth has never forgotten it. *[laughs]* First he looked at the *Birds* proofs and heliogravures they'd printed, and then people who we'd never seen before just started coming through the door. Gerhard'd made appointments without telling us and ended up staying way later than we did – they had to call the doorman so the building could be kept open. Ruth and I laugh about it every summer – they come out and print for me every summer – Gerhard taking over Pace as the sun went down! *[Dine smiles broadly and dusts walnut crumbs from his lap.]*
When I was a child we used to get the *Reader's Digest* every month and there was a feature called 'The Most Unforgettable Character I Ever Met', and someone would write in about it. Gerhard would be *way* up there on my list.
When did we see him next after this? I know, I know: he owed me some money.

Monte Packham: For *Birds?*

Jim Dine: No, not for the book. I've never taken money from Gerhard for books. I figure an artist is lucky and I make enough money anyhow; I don't need to take it from him, and he never offered it frankly. We've never even had a contract, which I think are bullshit anyway. Contracts are made to be broken, so why get into all that? But on this occasion he *did* say, if you make a print for *Birds* and sign it, we'll make a hundred books with the print in it and I'll pay you. I said great, so he owed me money for the prints.

I said I wanted it in cash and brought to a restaurant in Paris because Diana was having an exhibition at Monterosso's place –

you know MEP, the maison of European photography?

She was having a big retrospective and I put on a dinner for her. I told Gerhard I needed him to come early and he ended up arriving so

early that no one else was there yet.

DM: No. **JD:** No, you're right. We actually saw him just *before* that. I had a show of tool paintings two days before 9/11 at Daniel Templon.

On the eve of the exhibition opening Templon gave a dinner at a very fancy restaurant Lucas Carton, and Gerhard came. He had on a grey

work-shirt with a red pencil in the pocket.

DM: I thought it was black? **JD:** No. **DM:** Grey?

JD: I remember *exactly* what it was – an industrial grey work-shirt with a bright red pencil – it was a bijou, really chic. So we had a nice talk at dinner but the next day there was a metro strike and he ended up not coming to the opening. I was pissed off, I really wanted him to see the paintings. After that we saw him for Diana's show where he produced the money for the dinner at this schmucky restaurant. The time we saw him after that was when we came to Göttingen for *The Photographs, So Far*.

DM: We were here a long time for that… *[laughs]*

JD: Back then we were the old-fashioned version of Polidori – we never left!

DM: We were so naïve, we've learnt a lot since.

JD: We were virgins!

[Dine takes a sip of wine and leans back in his chair. Michener's eyes settle on the green vase of daffodils.]

JD: I once had a relationship with a publisher like Gerhard called Paul Cornwall-Jones for about six years in the sixties and into the seventies. He was my age, and a brilliant merchandiser and putter-togetherer of packages. He did two great books by Hockney, a few portfolios and books with me, Richard Hamilton, Dieter Roth – he was a kind of genius but he destructed financially because he was bent. And so I missed working with him, and never really got it back until I began working with Gerhard, where you get a kind of mirror of yourself. If you ever attain a level of brilliance, he matches it, stride for stride – I love that about him.

98

MP: Do you ever find it difficult to work with Gerhard?

JD: *[pauses]* Gerhard's always going west, he's always going towards the light. Like in nineteenth-century America you went west to gain consciousness and the light – that's how he is, he never stays in the darkness.

DM: I think Gerhard being difficult is something else though. In a sense we wouldn't be here if he wasn't difficult.

JD: What do you mean?

DM: We wouldn't be living in Göttingen.

JD: That's true.

DM: Which book was it where you got so upset? Jim got upset, really upset, almost hurt like a child when Gerhard didn't call him back once.

JD: He is so important to me, and I felt I was just stuck in his treadmill of production, and not only that: I valued his input and approval, like a child.

DM: Jim would call Gerhard and he wouldn't pick up his phone; he'd send him all these faxes and Gerhard wouldn't answer them.

JD: It was like having an affair when you know the person you're fucking is fucking somebody else. *[laughs]*

MP: What did you need from Gerhard at the time?

JD: Love, unconditional love! *[laughs]* Sometimes he'd call back and I'd feel better.

DM: It was like that, really.

JD: I was embarrassed that it made me that crazy, but I treasure his input into books so much and I know he knows I love them as much as he does, so I thought, 'I can't take this, I'm gonna have to walk away, it's too hard for me. I can always just paint. Forget it, you can't do this to me!' *[laughs]*

DM: Jim needed that affirmation, it's as simple as that. He wasn't getting it, and after a while I just realised we had to come to Göttingen to live.

JD: It's made such a difference. Now there's no waiting – if he doesn't take us now, he'll take us later, we'll come back again. Meanwhile I'm producing things, I have a life – that's all I wanted. Gerhard brought out *all* of my darkness, all of my saboteurs, everything. Because I respect him so much, because he pleases me when he's on form and we're working together. I was a mess until we moved here; now I live here, so what do I care?

DM: You're much more philosophical now.

JD: I'm older too – I've learned. *[laughs]*

DM: It brought out a big darkness that can arise when you think you're not valuable.

JD: Or valued. I didn't understand it at the time, and Gerhard would probably be shocked by that because he's always valued me, but I hated waiting in the queue.

DM: Jim has no patience.

JD: It's a joy now though, a pleasure. We love Göttingen, we're happy – we'll be here forever. It's crazy. One of Diana's daughters asked me last Christmas, 'What do you do for Christmas presents there?' I told her everything I bought for Diana I bought here. She said, *'Really?' [Michener laughs.]* I don't know where they all think we are – in some frontier town in the outback.

DM: Nobody can believe it. To live here in a German town – we never thought we would!

JD: I've embraced it.

MP: Does not speaking German make a difference?

JD: It means nothing to me, but not speaking French makes no difference for me in Paris either.

DM: I don't know ... I'd like to be able to speak the language.

JD: I couldn't care less – I have plenty of good conversations in English and I can always call up people in America who I can speak with philosophically or gossip with.

DM: It's a fascinating town here. One of our friends Arani Bose is a great medical inventor from New York who's worked with a professor at the medical school in Göttingen to coordinate certain tests. There are a lot of really quite extraordinary people here.

JD: Like our doctor.

DM: Oh I *love* Dr Rieger!

JD: We even have a doctor here, Gerhard's doctor, Dr Rieger.

Gradually, the conversation shifts from Steidl to other subjects: Bruce Chatwin is the first. 'I find him a very pretentious writer, but brilliant,' says Dine. 'I like *In Patagonia; Utz* less so.' Donald Evans – the painter of miniature watercolours in the form of postage stamps from fictional countries, who died in a fire in Amsterdam in 1977 and to whom Chatwin pays homage in *What Am I Doing Here* – was a student of Dine's in 1966.

Michener then talks of *Edie: American Girl*, Jean Stein and George Plimpton's 1982 book of interviews with those who knew Edie Sedgewick. For Michener, Sedgewick was 'beautiful, beautiful, hypnotic … a sprite'; for Dine, she was 'not so beautiful, just a dumb junkie, but socially very big'. Michener dated Sedgewick's brother Minty in 1955.

Dine and Michener go on to praise the Village Voice, their favourite English bookshop in Paris (W.H. Smith is 'not bad', Galignani is 'good for art books but not so good for literature', while Shakespeare and Company has 'had its day in some way'). They talk of Dine's dyslexia ('It's when you have a screw loose in your brain electricity-wise, and you can't perceive what you're looking at'), his three sons (an art dealer, an oboist, and an architect), Michener's two daughters (a paediatrician, and a lawyer and writer), the good quality of meat and Italian restaurants in Germany, the efficiency of German trains, the Pope, the Holocaust.

Towards the evening's close, Dine leans forward and shuffles the daffodils in the green glass vase on the table before him.

'Do you think I put too many in there?' asks Michener.

'No, I'm just trying to turn them out,' says Dine.

'Look they're coming now.'

'They're coming, aren't they?'

'I know.'

'Fantastic!'

'Isn't it?'

'What a difference from this afternoon!'

'I'm so excited about them.'

'Me too.'

'We can't live without flowers,' beams Michener, 'They were such tiny little things. I thought they'd come alive, but it's so cold in here I wasn't sure how long it would take. I put them in this green vase because I thought they looked so beautiful and I love them when they're all together, but maybe they're suffering from not enough space.'

Dine looks at his wife, laughs his warm, coarse laugh, and empties the contents of the red ceramic jug into her wine glass.

Robert Polidori

*'Gerhard's like a Communist. You have to go into the salt mines with him.
If you're willing to go there, then you're like brothers in arms and he'll do what needs be.'*

Göttingen, 12 December 2008

Dark wooden panelling lines the walls of the Georgia Augusta Stuben restaurant at Gebhard's Hotel, Goetheallee 22–23, Göttingen. Oil paintings and etchings in gold frames, some depicting the town's mediaeval architecture, adorn the white walls above the panelling. This is the formal dining room of Göttingen's only 'four star superior' hotel.

The booth that Robert Polidori has reserved for dinner is crafted from the same wood as the panelling and upholstered in olive-green leather. A cream-coloured cloth dotted with white fleurs de lys covers the table, and elaborate Christmas decorations occupy its centre: a poinsettia plant in a red ceramic pot the same hue as its leaves; a gold star-shaped dish containing peanuts; a fir sprig scattered with walnuts, gingerbread cookies and chocolate-covered marzipan; and three ripe mandarins.

Polidori enters the restaurant, flustered and a little late. He is direct, self-assured, erratic, earnest yet comical. His brown hair, touched with grey, is parted in the middle. He wears a faded mauve shirt, khaki pants secured by blue fabric braces, and a dark brown jacket with three buttons on each cuff.

After ordering his dinner – smoked salmon on a potato pancake, followed by *Grünkohl* with *Bregenwurst* – Polidori asks a waitress if she would mind removing the Christmas decorations from the table: 'OK. Can I just ask you something? Can we just take this away – you don't mind, right? I mean, I'm not so *Christmassy.*' The waitress smiles politely and begins to collect the objects. Polidori interrupts her however, and asks that two of the mandarins be left on the table: 'Maybe we'll just leave these two here – *voilà!* The others I don't care about.'

Polidori is in Göttingen to work on *Parcours Muséologique Revisité,* a three-volume book project of his photos of the Palace of Versailles taken over twenty-five years, beginning in 1984. His subject is the plush internal architecture of the

palace: the decadent trimmings, the gilt furniture, the paintings adorning the walls. His fascination with the subject is how these materials and objects have aged and changed over time, and the aesthetic, curatorial, and political motivations of the humans who have restored them.

Polidori is weary this Friday evening, after an intense week of working on the books. He pours himself a glass of Bordeaux, and begins to talk.

Robert Polidori: All right, now we're ready to go.
So what's the question?

Monte Packham: You seem to know how things work at *Steidl*.

Robert Polidori: Strangely enough, Gerhard's way of running things is how I run my studio, only he has many more people than I do. But I don't like running a studio, I like to be out shooting. Is Gerhard an artist?

Monte Packham: Is he an artist? No.

Robert Polidori: Yeah, so that's the difference. But I basically work the way he works, meaning that I permit myself to change my mind at any time, to supersede any priority by any other priority at will, and not to tell the others why I'm doing so. Because then they start second-guessing me and I don't like that. There should only be a few individuals who have this permission, not all of them. And anyway, life tends to bring in the unexpected and I just think it's the nature of the artistic world to be either too early or too late; things are rarely on time. You know we're not talking about a *railroad* here. Although I do think Gerhard's printing press is run like a railroad somehow. He's got a lot of work. I think he takes on too much – everyone says that – I think it's bad for his health really, too much flying around… *[sipping his wine]* So ask me a question.

MP: When you finish the Versailles book, is the project over for you, or is the book a chapter in an ongoing story?

RP: The quick answer to that is no, it's not finished. But that's not Steidl's fault.

MP: Does it have to be someone's fault?

RP: Well, a book should be the definitive work. Then you should go on to something new. However, I differ from what I think should be

the rule. One reason for this is that I revisit the places and even the locations of my photographs, the exact frames of what I've shot. It's the nature of my obsession, it's space- or place-specific. I'm interested in how environments vary over time, what changes and what doesn't change. That's the fundamental reason why a book is never really finished for me.

MP: Have you seen *Eye on Time* by Michael Ruetz? He photographs the same locations, mostly in Berlin, from identical viewpoints at different moments in time over many years.

RP: Oh I think I know it. I liked the idea but didn't like the photos or locations so much. I'll have to look at it again.

Normally I make a book too quickly. It takes me maybe three or four months, whereas it would take a year to do it comfortably: the scanning, image manipulation, proofs and sequencing. See the thing is this: book-making is not like putting on an exhibition. An open book shows two facing pages. Since I don't like when images go across the gutter – it violates them – I either put one per page (so two per double page), or I make grids with multiple images per page. Now I've had dealers in the past who like the catalogue format, where one page is blank and one has an image. But as I always include so many images, Gerd would flip if I did a book like that: *After the Flood* would have had 672 pages! That would've been one big sonuvabitch.

Since my work deals with lots of detail, I like to get the largest possible plate, which means two images per double page. So we're talking about pairs of images. When I first started shooting, or even as recently as ten years ago, I didn't really think in pairs. But when you look at two images at once, comparing image to image, the graphic quality of the pair comes into play. Superficially they have to look good together – I guess that's the 'graphy' part of photography. But this has to be balanced with content. Ultimately meaning has to be there or else the pairs add up to nothing more than decorative pages. Cinema is different because – except for some exceptional multi-screen films like say Warhol's *Chelsea Girls* – it's just one screen, like a single page that evolves in time and whose temporal pacing is predetermined by the director and editor. In contrast, the temporal flow of a book is determined by the reader as he or she turns the page: it's an act of will.

MP: Do you ever use gatefolds?

RP: No, never, Gerhard doesn't like them. They're expensive and a pain to do. So I haven't hit him up for that yet. *[laughs]*

MP: Books with gatefolds also tend to break after a while.

RP: I agree. So I spend a lot of time trying to sequence or structure the temporal flow of my books as best I can, attempting to influence the reader's experience of them. I guess one could avoid the whole thing altogether and just structure a book randomly – that would take a lot less time. I could have a computer do it.

MP: Or chronologically.

RP: Or chronologically, yes. Although that's not always as meaningful as one would think. The success of a chronological structure depends on whether the critical phases of a development are portrayed… What was your question again?

MP: Whether the Versailles project is finished when the book is printed.

RP: OK. No, for the following reasons. One – to use a musical analogy – I remember reading once that Bob Dylan refines a song over years and years of singing and playing on the road until he's satisfied or bored with it, and then he'll just drop it for a while, only to pick it up later. I copy that method. I also like to return to the scene of the crime. I always do that. It's like tempting fate or second-guessing myself. Each time I return to a place I see something I didn't notice or pay attention to the previous time. This methodology is well-suited to my work, because it's site-specific. Putting all these experiences together and examining them constitutes the book-making process.

Making a book is for me an act of self-criticism. A lot of people don't see it this way because they don't have a critical need, and so they let Gerd make or guide the book for them. I'm not in that category, though I wouldn't say he never guides, comments or edits. I'd say he gives me pretty much 95% free rein, although he does give me a set of limits right from the beginning, when we discuss what we think the book will basically be about. I've seen him do this with other photographers as well. It doesn't take him more than a few minutes to come up with a concept and size recipe – then comes the time-consuming labour of attempting to realise it.

I really don't care so much about my books being late, it doesn't bother me. I agree with what Gerd said once, that a book's meant to last five hundred years so it shouldn't matter in the general scheme of things if it's a week or month late. The other thing I appreciate at *Steidl* is the 'vertical integration' process: that

every stage of book production takes place there, except binding. It's my choice that he doesn't do the scans, although he does do the ones I'm late with. At the beginning we used to get into hassles about it: I didn't like the flatbed thing he had – I used to call it the 'dust box' – but he got rid of it. Now he has two very beautiful Heidelbergs, but I like my scanner better.

MP: What do you have?

RP: A British thing called an ICG, it's the only drum scanner still under development. I bought two of them, since I'm afraid they'll stop making them like with the Heidelbergs – then I'd be stuck with those new low-quality CCD scanners. I wanted to make sure I'd have enough tools to last me the rest of my life. *[Polidori rearranges his serviette on his lap.]* How old are you?

MP: I turned twenty-seven yesterday.

RP: Happy birthday. I'm fifty-seven. I thought I was six months older than Gerd but maybe he's six months older than me. He's a Scorpio, I'm an Aquarian. But we're pretty much the same age. He's born in 1950 then?

MP: Yes.

RP: I'm 1951, a prime number... What was I saying again? Oh yeah, that quality is going down.

MP: You mean generally?

RP: Yes, generally. Quality's going down because we're either at the end of a phase of industrialism or at the end of industrialism altogether. The problem is the dream of industrialism – its promise, its come-on, its seductive line. The idea that more and more people live longer and longer, becoming richer and richer while working less and less, and all the time giving less and less back to nature: let's say paying less 'taxes' in the larger sense of the word.

MP: Doing less and getting more.

RP: Right. Because machines do the work. A new form of slavery, a comfortable form of slavery. The upshot of this is that we're caught in a squeeze play, a diminishing returns curve, so quality has to go.

So to bring all this back to book-making, what I didn't like about publishers I worked with previously is that they follow an industrial capitalistic logic of how to run a small enterprise and minimise costs: this means that scans are made here, plates are made there, the books are printed somewhere else, they're bound somewhere else again, and so on. They're just middlemen, it's not a

106

hands-on thing for them. (I call what they do 'horizontal integration', and what Gerd does 'vertical integration'.) Perhaps this is where Marx was right about owning your own means of production: it gives you a great many possibilities and insights into them.

There are very few publishing and printing houses in the world that fit the bill, less than ten I believe. And Gerd is one of them. He does photo-books and I happen to be a photographer, so it works for me. I think it works for him too because I have a certain idea of book-making as an art strategy: I realise that taking a photograph is one thing, and making a book of photographs is another. Although they're not night and day – they're more like cousins or siblings. I believe Gerhard has this vision too.

Gerd likes to speak about what he calls the 'democratic' aspect of books. For instance I bet there are over eight hundred images in the Versailles book. To make an exhibition of all of them would be costly and space-prohibitive. Plus an exhibition is only ever in a few places and for a limited time. Although – and this goes against books – the exhibition prints *are* more beautiful than the plates in the books. Because of the way I shoot, there's more to see in larger prints and I keep making proofs over and over again until I reach more or less the 'perfect' print.

MP: How big are the exhibition prints?

RP: Big. Over a metre. But they're expensive, weighty objects. A book is democratic in that it's a visual reduction, or a size reduction if you will, of the artist's holistic vision. Whereas an exhibition contains full-size fragments of that vision. Although books reduce the size of the photographs, they show the full scope of the photographer's vision because they contain all the images that constitute the sum of the survey. Exhibitions might contain full-sized or full-bodied images, but ultimately they just show fragments of the total vision. And in any case, I'd never be able to get a hundred-thousand-square-foot space with a two-million-dollar budget for an exhibition – there's no museum big enough. Instead of turning the page, you'd have to walk from one photograph to the next and with over eight hundred images that would tire people – it's easier to turn a page than walk two metres.

Unexpectedly, Polidori's mobile phone rings and pulls him from his train of thought. He squints at the screen before answering: 'Yes, hello?' It is one of his

assistants who has been given the task of streamlining the phone numbers in his address book. She is finding the task more difficult than imagined. Restlessly, Polidori begins to explain to her the rules governing international phone numbers including country codes, area codes, local numbers, digits in parentheses, digits not in parentheses: 'You have to figure it out: different strokes for different countries / On modern cell phones there is a feature called 'plus' that allows you to plug into the international network / When you see the zero in parentheses, then you know it's the European tip-off to put the zero in front when you're dialling domestically / The US is the only anomaly, you know what I'm saying? / I'll look at it tomorrow, I'm too tired now.'

As Polidori hangs up, his girlfriend the painter Brittany Sanders arrives at the table, fresh from a yoga class in which she has participated with several *Steidl* employees.

'How was it?' asks Polidori. 'You just missed a very long, very boring description of international dialling.'

'Are you tired or drunk?' she asks with a smile.

'I'm tired!'

'You need to go to yoga.'

'I'll do yoga when my book's done.'

'That's a prescription for never going!'

Brittany inspects a menu and orders a salad. Gradually, the conversation moves beyond book-making. Polidori talks of the *Steidl* staff Christmas party tomorrow night ('I don't get to go? Too bad!'), and of his preference for New Zealand over Australian wine: 'It's not that Australians are stupid and don't know how to make wine, they just have the wrong climate. In my opinion good wines come from places with cloudy, rainy, sunny, sunny, cloudy, rainy, rainy, sunny, cloudy climates.' He expresses many of his thoughts as declarations: 'In today's world, you have exceptional people everywhere / You gotta play with Gerhard / Burlington Vermont! I've been there! Burlington Vermont is like Socialist America.'

After the meal is over and the bill has been paid, Brittany notices on the edge of the table the remnants of the Christmas decorations that Polidori had earlier dismantled.

'Where did you get these mandarins?' she asks.

'Oh, there was a whole thing here, but I got rid of it,' he says. 'But I kept these

for you, I knew you'd like those.'

Brittany smiles, thanks him, and places the mandarins in her bag. Polidori turns to me and asks, 'Is there more interview to go? Have I been good so far? Are we done now?'

Joakim Eskildsen

Fakse Ladeplads, 24 February 2009

The experiences of the Roma people depicted in Joakim Eskildsen's book *The Roma Journeys* are beautiful despite being mundane – Magda Károlyné in the Hungarian village of Hevesaranyos peeling onions and garlic in her kitchen, letting the skins fall on the floor before sweeping them outside with a broom; snails' shells knocking against one another in boxes on their way to France from Hungary, where the animals were collected by hand in the rain; and Sandrine, a young woman on the outskirts of Paris washing her baby's clothes in a tub brimming with soap bubbles.

The experiences of the Roma can also be shocking – the pregnant Yannoula Tsakiri, living in a rubbish tip between Aspropyrgos and Elefsina in Greece, was kicked in the back by a policeman and as a result her baby died; while Dionysia Panayotopoulou, a divorced mother of three girls, explains: 'This is where my mother disappeared a few years ago. She was run over by a bulldozer while collecting tins.'

Between 2000 and 2006, Eskildsen, accompanied by his wife Cia Rinne, travelled through Hungary, India, Greece, Romania, France, Russia and Finland, where he photographed the Roma people and the difficult, often appalling conditions in which they live. *The Roma Journeys* is divided into seven chapters representing the seven countries visited, each chapter beginning with an essay by Rinne followed by Eskildsen's photos. The couple acknowledges in the book's introduction that its journeys were 'by no means meticulously planned, and were instead the product of a number of coincidences'.

Günter Grass wrote the book's foreword, in which he laments the 'constant persecution, discrimination and systematic annihilation' of the Roma population. With around twenty million members, the Roma is 'the single largest minority in Europe and one that none the less does not receive sufficient recognition'. For European nations the Roma is an alluring idea – an exotic, mobile, indeterminate people – but an inconvenient and ultimately intolerable reality. For Grass, who founded the *Stiftung zugunsten des Romavolkes* (Foundation for the

benefit of the Roma people) in 1997, the Roma is ironically 'in a position to teach us how to cross borders, indeed, to abolish borders in and around us and to create the kind of Europe without borders that is not only the subject of empty oratory but an actual state of affairs'.

The journey through which Eskildsen's vision became a book was at times as impulsive and unpredictable as the experiences he shared with the Roma themselves.

Joakim Eskildsen: As you know, one doesn't see Gerhard so often, so I don't have too many stories to tell, but I've made some notes on a piece of paper to help me remember the main points.

Maybe I should start by saying that I studied book-printing and book-making at the University of Art and Design in Helsinki.

I graduated in 1998 and before I began the Roma project I'd actually made three self-published books, so I had an idea of what it takes not just to design a book but to produce one too.

Monte Packham: When you say 'self-published', do you mean you printed them yourself?

Joakim Eskildsen: Not quite. They were self-published in the sense that there was no publisher behind them. I made all the films myself the old-fashioned analogue way with a repro camera, and then took them to a company that exposed the plates. A professional printer then printed the book. But there wasn't somebody like Gerhard who took responsibility for anything, and we had to pay for it all ourselves.

After that we brought the printed sheets home to our apartment, folded them, put them in order, and took them to the bookbinder, where we bound the books with him. So we had our hands in every book, actually touched each book. But for *The Roma Journeys* we realised we didn't want to go down that road again and that we weren't really specialists – although I am proud of what we made back then.

In the summer of 2004 I was in a group exhibition in Helsinki, and Ute Eskildsen from the Museum Folkwang was there one day, showing some people around. I thought I'd approach her, as I was looking for someone who could not only publish the book, but who would also understand what it's

like to have produced one yourself. Luckily she'd heard of the books we'd made, and I asked her who she thought might be good for the Roma book. 'Gerhard Steidl' was her immediate response.

I thanked her and asked what I should do next. She said to send her some layout material, just something to look at, and that she'd show it to Gerhard. So I did that, and at the end of 2004 received a telephone call from someone speaking German. At first I thought it was for Cia as she grew up in Germany, and I passed her the phone. 'I'd like to speak to Joakim Eskildsen,' he said though, so she handed it back to me. 'It's Gerhard Steidl. I've seen your material. It's very interesting and I'd like to publish your book,' he then said in English. 'Wow … great,' I said – and I could tell he was ready to hang up the phone – 'What do I have to do?' And he simply replied, 'Call me when the photos are ready.'

That took almost two years, until the spring of 2006. I called Gerhard but was worried he wouldn't remember me, as our first conversation had literally been no more than thirty seconds. He did remember me though and said, 'Call me when the layout is ready.' That took until the summer of 2006. I phoned him then and he said, 'Good. I will contact you and you will come to Göttingen,' and hung up.

A few weeks later I got a phone call asking me to go to Hamburg on a particular day, as Gerhard wanted me to meet Günter Grass. My mouth dropped open when I heard Grass was considering writing a foreword for the book. So I went to Hamburg, spent the night there, and early the next morning walked to the train station where we were supposed to meet. I waited and waited but no one came, so eventually I called Göttingen and was told that someone called Frank was on his way and would contact me. Frank called me shortly afterwards, picked me up, and we drove to Grass's place where I waited around again – there were lots of people there to see him.

MP: Was this at Grass's home?

JE: No, at his museum in Lübeck. Then Gerhard suddenly entered the room – this was the first time I'd met him. 'Hallo, Gerhard Steidl!' he said, and in the same breath, 'This is Günter Grass, please show him your book and tell him about your experiences.' It was all very straightforward somehow, no small talk. Grass was keen to hear my stories, his wife Ute too. He showed us around afterwards and then Frank drove Gerhard and me back to Göttingen.

We shared a bottle of Grass's wine on the way and Gerhard said he'd probably fall asleep – he always sleeps in the car – but we started discussing different kinds of paper, and I told him what I had in mind for the book. It was wonderful to hear all his knowledge about paper, very inspiring. When we arrived Frank said to me, 'Don't be surprised if you meet a different Gerhard Steidl tomorrow: it's rare to see him this calm.' And he was right, the next day Gerhard was unbelievably busy.

MP: Some say there are two Gerhard Steidls: one with the white lab coat, and one without.

JE: Aha. I know him very little in this respect, but realised quickly he has much to do and is extremely focused on his work. I stayed in Göttingen for a week, but we only managed to speak on the Friday evening about an hour before I had to leave. That surprised me a little at the time, although it had been very exciting meeting all the other artists and everybody working there. Gerhard looked through the layout and liked what he saw. He only had one criticism, the typographic sections between chapters: 'Please think about these pages,' he said. 'They need more space, more air. At the moment it looks like a magazine layout.' And he was exactly right. 'But it will increase the page count,' I said, 'and the book is already at four hundred pages.' He said he didn't care: 'We will make the book we have to make.'

After that the texts had to be translated because the book has German and English versions. We also started the colour corrections: things went back and forth with Julia as I had many corrections and sometimes made changes when I shouldn't have… All in all it took a long time.

In June 2007 we returned to Göttingen for what we thought would be to print the book, but it was actually for more colour corrections. At the time there were only a few left to be done, but there was a big problem with the black-and-white pictures. The book is printed in the four-colour process throughout, so the black-and-white images are also four-colour. We made the colour separations with Jonas but couldn't work out why the black-and-whites weren't convincing. We tried different things but nothing worked and after a while I thought I'd just let it go – it wasn't perfect but we felt we couldn't do any more.

MP: Were they too red, too green?

JE: My black-and-white photos have bluish shadows and yellowish highlights.

113

But on the proofs they came out sort of purple, and the relationship between dark and light wasn't quite right. Jonas and I tried to find a solution but gave up in the end. That evening however, Gerhard had a look and said all the black-and-whites had to be remade in a different way. I would never have asked for this, but they were redone and in the end looked perfect.

Now the book was ready to print – that's when the difficult time for us began. Gerhard said he would most likely print in three weeks and asked me to call him then. So I did and he said, 'Probably next week, give me a call then.' I called him the following week and he said, 'Probably next week.' It went on like this until August, when he said, 'There's no point you calling me every week – call me every two weeks.' So I did, but eventually he said, '*I'll* call *you* when I know.'

MP: How long did this go on for?

JE: Six months.

MP: Before the book was printed?

JE: Yes. This was, I learnt later on, one of the longer delays for a *Steidl* book. Although it wasn't really a delay, because we'd been slow from our side too and made late changes. Nevertheless we didn't have any books for the first two exhibitions. Which didn't bother me and I told Gerhard that – we just wanted the best book under the best possible circumstances.

In the end I got a phone call one Friday afternoon saying the book would be printed at six o'clock on Monday morning. 'But Monday's in two days!' I said. So we packed our things and went to Göttingen on the Sunday. Then there was another delay and we actually only started printing on Tuesday – this was at the end of November 2007. We printed from Tuesday morning until Saturday. Gerhard was very attentive: at the beginning he was by my side on press, checking off every sheet, but there were surprisingly few changes to be made and in the end I did it alone. We printed through the nights: I stayed in the library, sleeping when I could, and went down to press whenever the printers called me.

We also printed the cover, for which we used a special paper. When travelling with the Roma I used to carry small sketchbooks with me that got very battered and worn from life on the road. We thought it'd be fitting to have a cover with a similar tactile quality, so we chose a sensitive Hahnemühle paper that shows signs of wear over time.

After we left Göttingen the bound books arrived just a week later. I called Gerhard the minute I had one in my hand, and told him how perfect it was: my exhibition prints and the pages in the book were unbelievably close.

MP: It seems that making books for you is as important as taking the photos themselves.

JE: Definitely – I visualise my projects as books even before they're half-finished. For me the book is the backbone of the project. Exhibitions are important, but the book always comes first.

MP: Why so?

JE: I like the form of the book: that you have a particular order of pages, and texts and images that need to be brought together. And there's always a large number of books printed which means you can share them with more people, it becomes a democratic thing. People often ask me if they can buy one of my prints but they tend to back off once I tell them the price. So I say, 'Just buy the book! It's got hundreds of pictures! Buy *two* books, so you can cut up one and frame the photos!'

I feel a book is something familiar, something homely, something that belongs to you like your toothbrush or your shoes. A book is intimate: an intimate object for its owner and an intimate home for the images it contains.

The Roma Journeys contains two hundred and seventy-four photographic plates. Many of them depict not only the Roma, but also the objects – practical, religious, sentimental – that surround these people and with which they surround themselves. Of the hundreds of objects represented, I count only one book. There is a television in Magda Károlyné's house in Hevesaranyos, Hungary. Covered in imitation wood veneer, it is a large outdated model on which sit a cardboard tray filled with eggs, two figurines of the Virgin Mary, and a plastic doll in a red floral dress. In Frépillon, France, a woman called Romni stands outside a dilapidated caravan. She holds a metal teapot in her left hand and a baby's bottle in her right. Around her, on filthy carpets placed on the ground, lie an empty detergent bottle, an audio cassette, a toy wand, and crumpled clothes. In Kirkkonummi, Finland, Ritva and Henkka Berg fiddle happily with their mobile phones in a landscape illuminated by afternoon sunlight. In Vodstroy, Russia, Zemfira Demonie stands proudly in her living room filled with crockery, cut

glass and taxidermied animals including a boar and a wolf. In Transylvania, Romania, a girl wears luminous red ribbons in her black plaits.

And in Moldavia, Romania, the young Mădălina sits outside before a flaking wall. She wears unwashed pants and a pink knitted cardigan. Her facial expression is inquisitive, vulnerable, opaque. She pulls her knees close to her chest and curls her fingers on her grubby feet. To her right a plant emerges from the dirt; to her left lies an open dictionary.

Juergen Teller

Göttingen, 27 February 2009

Juergen Teller's voice is deeper than I expected. The irreverent, deceptively mundane nature of his work and its black humour – his mother posing as a soccer goalkeeper before his father's grave; an unremarkable lemon branch laden with fruit; Charlotte Rampling feeding caviar to the naked, laughing Teller with a mother-of-pearl spoon – belie the photographer's composed character. His words are paced and considered.

Teller sits in the library at Düstere Strasse 4, facing the alphabetised bookshelves that line one wall. He wears a dark blue suit jacket over a grey T-shirt, and a gold chain around his neck. With a round child-like face, blue eyes and spiky thinning hair, he looks kind though weary. On the table before him lie colour print-outs from his upcoming book *The Master II*. These include photos of the naked Lily Cole perched on a rock like a mermaid, a dead octopus on white bed sheets, a nondescript parking lot, Björk with squid ink pasta tumbling from her mouth, and Raquel Zimmermann standing naked before Classical Greek sculpture in the Louvre.

Three floors below the library, Teller's *Election Day,* the book based on his photos for the Vivienne Westwood Spring-Summer 2009 advertising campaign featuring Pamela Anderson, is being printed.

Monte Packham: When did you first meet Steidl?

Juergen Teller: It was in '97 I think, when I made two Scalo books.

MP: With Walter Keller?

JT: Exactly. I did the books and came to Göttingen to print them.

MP: Was Walter here too, or did you come alone?

JT: He was sort of in and out. I'd see him more in Zurich, London or New York where we had meetings, but on this occasion he just said, 'OK, now you fly to Göttingen and print the thing.' I remember arriving and being fascinated by the technical side of book-making: what you can and can't do, the different ways you can

print black and white, what the four-colour process is and so on. Most people don't realise how difficult it is to print a book and get a good result: I've heard people say, 'Well, you just give your files to the printer and then the book comes out and it's done.' But it actually takes a long time to get it right. And then there are all the decisions about the spine and binding to make.

MP: Do you enjoy coming home to Germany to make books?

JT: It's sort of a rare thing for me. I know some who've said, 'Oh my God, Göttingen is so boring, there's absolutely nothing to do,' but I enjoy it. I don't get back to Germany that often now, and I'm hardly ever in a small town like this that reminds me of where I grew up. The closest 'big city' for me back then was Erlangen, which is about the same size as Göttingen, say one hundred thousand people. But my hometown Bubenreuth is even further in the countryside and has about three thousand people. So I like this kind of smallness, compared to being in a big city. And I basically don't do anything in Göttingen other than work on books, which is quite nice.

MP: Do you always have the idea of a book in your head when you take photos, or does that come later? With *Election Day* for example, did you think, 'These are photos for the Westwood campaign, but we're going to make a book as well'?

JT: With Westwood I just went there and did the campaign because that's what I was there to do. But in the afternoon of the shoot (it was just one day), I said to my assistant and to Vivienne and Pamela too, 'Listen, this will be a book in the end.' I had a pretty clear feeling it would work as a book or some kind of catalogue.

MP: Because the pictures tell a story?

JT: Yeah, there's a common-sense thread through it all. I'd never seen photos quite like them before: with Vivienne and Pamela, these opposite poles of people, this weird mix of flash and no flash, everything ugly and beautiful at the same time – a sort of mess.

Or when I was doing the self-portraits with Charlotte Rampling for Marc Jacobs, I knew they'd become an exhibition or book. That's when I called her and said

we should do more photos – we ended up working for six months. Whether it becomes an exhibition or a book is sort of the same thing for me: something concrete at the end of it all.

MP: So the book emerges from the pictures themselves, not through some pre-designed plan.

JT: I guess so. Or with the *Nürnberg* book – I'd had the idea to do something about the Nazi rally grounds for years but didn't know exactly what. When I eventually went there and found all the little flowers growing out of the concrete, I knew pretty much immediately I wanted to take photos over an entire year, showing the weeds and flowers in spring, summer, autumn and winter. And I knew it'd be a book.

MP: In the Westwood campaign there are some shots outside, say on the beach, and some inside in the laundrette – do you work out details like those in advance or do they unfold during the shoot?

JT: Sometimes I choose locations very carefully and know exactly what I'm going to do. But with Westwood I had no idea. We had to go to Los Angeles to be with Pamela because she *is* America in a sense, and specifically LA. She just suggested we do it in her trailer park.

MP: She lives in a trailer park?

JT: Yeah.

MP: In a *trailer?*

JT: Yeah. It's her laundrette too.

MP: That's where Pamela Anderson does her laundry?

JT: Yeah, it's her laundrette. It's a kind of upmarket trailer park, but a trailer park none the less. The inside of the trailer is bigger than this room but it's still not huge. She lives there with her two kids, one's a teenager and the other one's eight or ten or something. They sleep in bunk beds. *[Teller begins arranging pens and paper clips on the table to illustrate the floor plan of the trailer.]* There's the kids' bathroom and her bathroom, her bedroom, and then one big room with the kitchen *here,* the entrance *here,* a bit of a terrace, and the living room. It's big enough obviously, but it's not exactly a house. She loves it. She lives there because she's building her house next door. But she likes it so much with all the neighbours and community, she's going to stay there and just use the house for parties and guests. It's right next to the beach and she's got her golf cart and the

119

kids have their motorbikes and surfboards. That's their life.

MP: So the campaign was practically shot in her backyard?

JT: Yeah. That's how I was able to do so many pictures in so many different spots in one location. There are a lot of outfit changes so it was basically a matter of going back to the trailer after a shot, changing, and moving somewhere else – all in the radius of say Düstere Strasse. I had to improvise, as Pamela didn't want to send me pictures of where she lives up front. She just said, 'Trust me, trust me, we're gonna do it here.' And we did.

MP: Did Westwood herself have much input into the book?

JT: She has a graphic design department that we work with for the ads: single pages, double pages, where the logo should go and all that. We met at my studio and again at her office, and after a while I said, 'Listen, I've had this meeting with Gerhard…' She loved the idea as she was delighted with the other book we did together, which is apparently sold out. [*Vivienne Westwood Spring-Summer 2008*]

MP: She's a big reader herself, isn't she?

JT: She is. So she thought it'd be good to put what we've done into some kind of permanent form, not just ads in magazines. But she left the book itself up to me, whether it should be called 'Pamela and Vivienne' or 'Election Day', and so on. I passed everything by her, but otherwise it was up to me.

MP: 'The Master' series of books also crosses over into advertising, although it's somehow different.

JT: That's not really advertising at all. It started with a show I had at Modern Art in London called 'The Master'. I wanted a catalogue for it, but a kind of booklet, not a big fat art book. The name 'The Master' came when I met William Eggleston, who I believe is in a way the master of colour photography, or at least the master for me. After the exhibition I realised I had other masters like Araki and Kurt Cobain, Charlotte Rampling, Helmut Lang and Louise Bourgeois – they're all masters in their own fields – or even Fergus Henderson who just got a Michelin star and is a friend of ours and a fantastic cook. So it could be anyone in any field, but it also refers to me: that I'm the master, that whatever I say is masterful or beautiful. In a way I'm creating my own magazine, my own little thing.

MP: Why are the books such 'little things', these small flexible booklets?

JT: I didn't want them to be too precious. I wanted them to be accessible and inexpensive so students and young people could afford them. And I'd had enough of the big books we'd done like *Nürnberg* and *Louis XV*, which is leather-bound and even has gilt edging. I also like working with magazines, so for me there's always a place for something a little more casual and throw-away. Although I think because of the very casualness of 'The Master' you end up treating the books with extra care, so in the end they're not throw-away at all.

MP: How do you know when it's time to release the next book in the series?

JT: It's just when it feels right for me.

MP: Intuition?

JT: Yes. And they'll all have the same format and typography, but with different coloured covers. That's the good thing about Gerhard: if you want to do something a little different and you can explain it to him, then he'll show you how it can be done and what doesn't make sense in terms of book-making. He listens to the desires of the artist.

Göttingen, 19 March 2009

When Teller was in Göttingen printing *Election Day,* his infant son Ed had asked him to bring a special gift home to London. That special something was *Gelbwurst,* a traditional Bavarian sausage of pork, veal and mixed spices, not readily available in England.

On his last day in Göttingen, Teller bought Gelbwurst from the butcher Wulff in Groner Strasse, and placed it safely in the fridge on the top floor of Düstere Strasse 4. In the haste of departure however, he forgot it.

That evening, Ed was distraught over his forgotten Gelbwurst. The next morning, Teller called Steidl for help. That afternoon, the Gelbwurst, protected by ice packs in a padded cardboard box, was on its way to London by express courier, to arrive the next morning in Ed's eager hands.

Robert Frank and June Leaf

Paris, 10 March, 2009

Robert Frank and his wife June Leaf have returned to their hotel, a stroll from the Place de la Madeleine. They have spent the afternoon walking along the Canal Saint-Martin with their friend François-Marie Banier. Frank, eighty-four, and Leaf, seventy-nine, are weary though alert, and pleased to be back in their hotel room where Banier and Steidl have joined them.

The room's carpet is beige, and the queen-size bed white. Light wooden panelling lines one wall, and another boasts tall windows opening onto the Boulevard Malesherbes. On a small table sits a vase of purple poppies.

Frank has a ruffled, endearing appearance. He wears dark khaki pants and a grey flannel shirt with black buttons. His grey hair is wispy; his sideburns are bushy. Leaf has a kind, time-worn face and wears a lilac woollen jumper. Banier, as ever, is flirtatious and restless. He skips from one activity to the next: taking photos of Frank with his Leica M7 camera, munching a Granny Smith apple, repositioning a reading lamp, fiddling with his trilby hat, and then spontaneously asking Leaf if she would like to dance (she declines, saying she is too tired, but promises to show him how to charleston later in the evening).

Frank and Steidl sit next to one another on the edge of the bed, leafing through a maquette of a book of stereo-photographs by Henry Frank, Robert's father. These images have been scanned from glass plates that Robert brought with him from Switzerland when immigrating to America in 1947, and which Steidl carried to Göttingen in the summer of 2008. The plates show visions of a passionate amateur photographer in the 1920s and '30s: snow-capped alps, an automobile fair in Paris's Grand Palais, hot-air balloons, views of Venice and Pisa, and family photos including the smiling infant Robert.

The conversations between Frank, Leaf, Banier and Steidl this evening move between English, French and German.

Robert Frank: What's the title of the book?

Gerhard Steidl: 'Father Photographer'. 'Henry Frank' and then 'Father Photographer', instead of 'Photo Album'.

Robert Frank: That's nice. I don't see any double pages though.

Gerhard Steidl: They're here at the back.

François-Marie Banier: The paper Robert – you want it creamy or you want it white?

Gerhard Steidl: *[hands Frank a sample of paper]* This is the paper we used for *The Americans.* I would like to use it again, it's a little creamy but not really yellow.

François-Marie Banier: *[stroking the paper]* Exactly like that?

Robert Frank: I think it's wonderful. And the text?

Gerhard Steidl: It's at the very end, in three languages. I think we should start with German because your father lived in Switzerland, then have English, and finally French.

RF: Yes.

GS: And at the front of the book: 'Edited by Robert Frank and François-Marie Banier'.

RF: Yes. **GS:** And will we make the book just privately for ourselves, or is it for the bookshops as well?

RF: No, I think it should be for the bookshops. I've done that before for my family, made two or three copies of a book and bound them in leather, but this is something different.

GS: I think it's more democratic and these are good photos, yes? The public will be interested.

FMB: *C'est très très bon, c'est merveilleux!*

GS: I have the versions of the text here: English, German and French.

FMB: *[taking the French translation] Alors,* I am going to correct it in *one second.*
[Steidl passes Frank the German text, and Leaf the English. Frank fetches his silver-framed glasses and begins to read. He holds the stapled sheets in his right hand and makes occasional corrections verbally, which Steidl notes down. Frank struggles to edit a paragraph in which he describes a boyhood experience in Switzerland: 'I heard Hitler every day on the radio, the voice of terror. He was just behind the door.

For us Jews the situation was all the more serious as it meant certain death.'
After several minutes, Leaf, who has been reading in silence from the head of the bed, addresses
Frank in a hushed, candid tone.]

June Leaf: I'd like to say something about this, just one thing. I have a very strong feeling about this all of a sudden.

You've made this very beautiful book that's like a little jewel, that's what it is. Then through the text you bring in Henry Frank, your father. But you express a lot of anger and bitterness – there are some observations about your parents that aren't so wonderful: that your mother didn't like young maids in the house, that she didn't want him to go out… In a way you put him down a little. There's a conflict between the text and the beautiful jewel of the book – I think you bring too much of yourself into this somehow.

RF: *[thoughtfully]* I don't know. I do think one paragraph is wrong though: 'I believe the Swiss mentality compelled me as a photographer to be not simply as good as the rest, but better. That was my ambition. My father was the role model: he was diligent, intelligent, a good photographer, and wrote fine letters. He was strong in contrast to my mother, who was miserable as she was losing her eyesight and eventually went blind.'

FMB: Robert, I want to respond. I am not in the part of June, because I think when you show something like these photos that are very odd and old, you have to give some impression of who this man was, of your family, your feelings. *Moi, j'adore ce texte* and I would not change a thing!

JL: I know you feel that way.

RF: The text is all right. But this thing about my mother – that she was 'miserable' – it's unnecessary. It should be 'sad': 'He was strong in contrast to my mother, who was *sad* as she was losing her eyesight and eventually went blind.'

JL: But there are a couple of times where you take a little dig at your father. I realise it's late for me to be saying this…

FMB: Robert – I think it's the least you can say, and very touching. I think it's absolutely fantastic as it is: *moi j'adore.* I'm sorry but *j'adore!*

JL: But you're a novelist. For me it's the simplicity, the idea that the book is so much a jewel and the text is a whole other song. It's not that I think there should be no text – I just think the tone could be a little less cynical. Just a little.

That his mother wouldn't let his father escape: that's Robert going like this. *[Leaf playfully shakes her fists.]* I don't like that line: 'My mother wouldn't let him escape.'

FMB: But photography *is* escaping! To make a photograph is for his father to show he was interested in many different things, that photography is a window to the outside. And it's charming: his wife loves him so it's nothing bad to say that. *Moi j'adore ce texte!*

[Banier spontaneously wraps his arms around Leaf's waist from behind, and lifts her into the air. She screams with laughter.]

JL: Do that again, I like that! I love any man who can lift me up like that!

FMB: *[putting Leaf gently down on the floor]* Alors, now Robert we have to speak about the future! *Alors,* the future: bravo, goodbye and *parfait.* The future!

JL: *[with gusto]* The Banier movement is coming!

FMB: *[to Steidl]* You know the last time I was at Bleecker Street I took some negatives to be developed. One of them was Robert's. We developed it and got the contact sheet. And what did I see? *Four masterpieces* on the contact sheet! *[Frank begins to laugh, a wheezy chuckle that turns into a cough.] Mais* Robert you saw it too – you told me it was true today!

RF: I don't call my photographs masterpieces.

FMB: Robert, you have to get out more, not just sit by the fireplace at Bleecker Street! It's so hot up there you can cook an egg *à la coque!* You sit there swallowing, swallowing, like a frog! *[Frank laughs.]* Today we went to two museums and to the Canal Saint-Martin – *moi* I am exhausted!

JL: *[to Banier, playfully]* You're in a fantasy, complete fantasy. It was hot up there maybe once, and only if you go *close* to the fire. But you know what? You always sit right in front of the fire!

FMB: *C'est vrai. [Steidl laughs.]* Second thing: the other day we saw a lot of Polaroids chosen by you. Robert, how you arranged them was like a Vuillard, like a painting. But what interests me most – because you are more creative than anybody else – is what you said about changing the size of the Polaroids. Do you remember?

RF: Yes, that one should change the format of the Polaroid sometimes. Get away from the traditional square format with the white frame. Take croppings or details: take a road a little more dangerous than the normal Polaroid approach. But I'm not sure.

GS: But it's worth trying?

RF: Yes. I'd have to go to Mabou, there are lots of Polaroids there. But I don't want to make another book just because I've got two hundred Polaroids lying around, that's not the point. If I make a book, I want it to be good. And I think the Polaroids have to change in size sometimes. People say a Polaroid's just a Polaroid, but it could also be an *Ausschnitt* of a photo.

JL: What's an *'Ausschnitt'*?

RF: A cropped photograph, completely cropped without the border.

FMB: And I am sure there are a lot of photographs in your contact sheets that have never been seen before. You showed me some photographs *unknown* – the one of Truman in his car for example has never been shown before.

JL: Couldn't you put the Polaroids in a book together with black-and-white photos? Why do they have to be separated? Sometimes when I look at the Polaroids I think it would be wonderful if Robert wrote something on them, although he does now and then. Something is often missing for me, a word or a thought. But maybe you can't do that if the words don't come straight away.

FMB: *C'est bien.*

RF: The whole point is not to say they're Polaroids.

FMB: *Voilà!* And *en plus,* when you see the Polaroids together it's like *life,* because emotions are just like that in life: a woman is crying one day, after that she is smiling, after that she is in the middle of a swimming pool. So we have a lot of emotion: you can mix the Polaroids with old black-and-white photos that no-body has seen yet. But we have to work, not stay by the fireplace!

[The telephone on the bedside table rings. Banier pounces on the phone before Leaf has time to react, and answers it in a high-pitched, coquettish voice.]

FMB: 'Hello? Ah very good, you can bring them up, thank you!'

RF: *Ma sœur?*

FMB: The French are so clever! She called me 'Mrs Frank'! Finally I have arrived! I am the new Mrs Frank!

JL: *[laughing]* I'd like you to be Mrs Frank actually.

FMB: I *am* Mrs Frank. *[Banier suddenly gets up, packs his belongings, and bids all good-bye.] Au revoir Robert!*

RF: *Au revoir! [Banier leaves.]*

GS: It's good fun with Banier, no?

JL: He's powerful.

RF: He works constantly, he's a worker. And he's a good editor: quick and nearly always right.

GS: He does it from the heart, not only from the head.

JL: I like his energy very much, but sometimes you have to slow him down.

[There is a knock at the door. Leaf opens it and a hotel employee enters with a bouquet of flowers. Leaf takes the bouquet and places it on the table next to the purple poppies. She then approaches Steidl, a little nervously.]

JL: Gerhard, I have something to show you, and it's *mine. [She fetches a crumpled photo of a sculpture and a battered artist's sketchbook, and places them in Steidl's hands.]* I made this sculpture this summer, Banier took the photo. And when I finished it, I found this sketchbook, which I made in 1974. I like it because it's all about the sculpture, which I ended up making thirty-five years later. I didn't like the sculpture so much at first, but when I found the book I thought it was astonishing: this book, forgotten for thirty-five years, brought back to life. I thought I would like to publish it.

GS: A facsimile?

JL: Yes. You wouldn't have to edit it, it's already finished.

GS: *[leafing through the book]* It's very nice.

JL: It has some good things in it, read the writing.

GS: It's like a diary, a visual diary.

JL: Yes, but it's very personal. It's about our shared life.

[As Steidl and Leaf talk, I ask Frank about his book-making with Steidl.]

RF: *[after a moment's thought]* Well, the book is the final step in the photographer's work. So it becomes essential to have somebody who respects your work and can make that final statement for you. It's important to trust the person who makes the decision to present your work in that way. And Steidl has a love for it that is not driven by making money. His motive is to produce the work itself: that it will be the best you can hope it to be.

MP: Has the book always been the final step in your photography, or did it become that way over time?

RF: The book has always been more important to me than selling my photographs. The book is what ensures your work will live longer, longer than any other means really.

MP: And do you like that a book is something many people can possess? If you make prints of your photos, then only a few people can have them, but you can make thousands of books for thousands of people.

RF: Yes, a book can be passed around. It's in libraries. It can be given away: someone can give it to a friend, loan it out and get it back. A book lives. I'm lucky in a way because my books live a long time. It has to do with the quality of your work, but also with how your books are produced.

MP: Do you have a favourite book of yours?

RF: It's probably always the last book I've made. If I were to work on a new book, then it would become my favourite.

Steidl and Leaf speak for another twenty minutes about her book, before Steidl has to depart. He thanks her, and packs the blue sketchbook into his bag, along with the maquette of *Henry Frank, Father Photographer*. Leaf is delighted that Steidl likes her book, but is nevertheless anxious: 'Think about it,' she says. 'Honestly, whatever you think is right is OK with me.' Frank, equally delighted for his wife, thinks the book might be difficult to reproduce because of its tall, narrow format. Steidl hugs them both goodbye and replies, 'It's not difficult. It's unusual, but it's not difficult.'

Klaus Staeck

Göttingen, 18 April 2009

Klaus Staeck has caught the train from Heidelberg to Göttingen this Saturday to discuss his current book projects with Steidl. The two men sit at the dining room table on the top floor of Düstere Strasse 4: Steidl at the head of the table, Staeck to his left. Steidl, fifty-eight, wears grey jeans, a black T-shirt and his white lab coat; in its breast pocket are four felt-tipped pens: two green, one red, one blue. Staeck, seventy, wears a striped shirt and navy blue trousers held up by scarlet braces. His grey-blond hair is thin, his glasses are rimless. Scattered across the table are books, notepaper, photos, plastic sleeves, pens and pencils.

Staeck and Steidl met in 1970. This afternoon, they are discussing *Schöne Aussichten*, the catalogue for Staeck's exhibition of the same name at Berlin's Berlinische Galerie from 29 May to 31 August 2009. Both the catalogue and exhibition are retrospectives of Staeck's artistic output from the early sixties to 2009, including prints, posters, postcards, collages, ready-made objects and photos. Steidl thinks the catalogue should be a paperback with a matt uncoated paper; he shows Staeck two books with similar soft covers and paper stocks as examples: Geert van Kesteren's *Baghdad Calling: Reports from Turkey, Syria, Jordan and Iraq* (2008) and Donovan Wylie's *Scrapbook* (2008). For Steidl, the gritty, unpretentious character of these books mirrors the satirical, anti-establishment stance of Staeck's oeuvre: 'Your work respects nothing, so this can't be a glossy coffee-table book.'

Suddenly, Steidl excuses himself from the table and goes downstairs to his office. Staeck fetches himself a bottle of mineral water and a glass from the kitchen. The interview begins.

Klaus Staeck: I met Steidl in 1970 as far as I can remember. Back then I was making screen-prints with quite controversial themes like Vietnam. Steidl saw what I was doing and simply asked if he could start printing for me. He had a small screen-printing operation set

up at the time, and may have already been working for other artists.

We got on right from the beginning, because he's the ideal partner for me as an artist. He was politically engaged – which is rare for printers and publishers – so there was an instant connection between us, one that continues today. Steidl's never called himself an artist, but rather a 'craftsman' in the best sense of the word, one who realises others' ideas with all his skills and knowledge. Many of my posters bear his signature as much as mine. In fact there were long periods of time, particularly in the early days, when I'd just send him a sketch – by express post to begin with, later by fax (we were among the first to use the medium) – and soon after he'd send me back the finished poster. We took our credo from Walter Benjamin's *Work of Art in the Age of Mechanical Reproduction:* the idea that there are no 'originals' that can be sold or traded. Back then many people committed themselves to such beliefs, only to relatively quickly reintegrate themselves into the mainstream art world. A strategy of self-marketing has also always been important for us. The early 1970s was a time of independent artists' editions and galleries, most of which have since disappeared – but somehow we've managed to survive and I think one reason for that is because we've always done our own marketing.

Monte Packham: How large were the print-runs of the posters?
Klaus Staeck: Sometimes enormous – tens of thousands – although we did start out relatively small. Our greatest piece of luck was really the intense enthusiasm that Willy Brandt brought into German politics at the end of the 1960s. In this environment (and actually even before, during Konrad Adenauer's time as chancellor) people began to realise that democracy was something to participate in, not simply to observe. As a result, political groups came into being that weren't aligned to particular parties but instead defined their own directions. They needed visual material to communicate their causes and we were able to fulfil that need. Our first big poster campaign was in 1971. By this time Steidl was already making screen-prints for me, and somehow we came upon the idea to test our posters in the art world: to challenge art on its own territory. So we took an art motif, a 1514 drawing by Dürer of his mother – there was a

big Dürer exhibition on at the time at the Germanisches Nationalmuseum in Nürnberg. We desecrated the image by printing the question *'Würden Sie dieser Frau ein Zimmer vermieten?'* ['Would you rent a room to this woman?'] over it in red. We then made A1 screen-prints to fit on those cylindrical advertising columns you find on the street. At the time I didn't even know you could rent the columns, but Steidl – always the practical one – simply rented three hundred of them through the printing-plant we'd used to produce the posters.

This was an important test for us: to see if the public would actually take notice of such posters – images that didn't advertise products or announce events, images where you weren't even sure who was responsible for them. Were people going to take this seriously? (I think if it hadn't ended up being a success, my life and career would have unfolded very differently.)

Once we'd hung all the posters, hundreds of people called up the city council, advertising companies and the local newspaper. The main thing they wanted to know was who was paying for it all: they saw the advertising columns as objects of authority and so assumed the city itself had paid! And then of course there was the provocative question on the poster, which was both a critique of the nature of exhibitions and of art in general – and art back then was much more unsettled than it is now.

These were times when one questioned almost everything. 1968 itself was actually rather unexciting in parts, but it did set in motion a course of events that allowed people to really grapple with the idea of democracy. Many took Brandt's famous motto *'Wir wollen mehr Demokratie wagen'* ['Let's dare more democracy'] to heart.

Through Nürnberg we realised that people were actually going to take us seriously – after all there's no point spending the time and money to print and display posters if nobody's going to take any notice of them. We had two goals: to reach the general public, and to do so without financial backing. There was also the challenge of distribution. Back then we weren't blessed with the internet, so we printed a little pamphlet, an A4 sheet folded in the middle offering four or five posters with adhesive labels, stickers and postcards: all in all a pretty poor selection!

In Nürnberg we'd tested the posters in the art world, and now we wanted to see if they'd hold their own in the political arena. During the 1972 state election

in Baden-Württemberg we hung about two hundred posters – *'Die Reichen müssen noch reicher werden. Deshalb CDU'* ['The rich need to be richer. Vote for the Christian Democrats']. This was our political beginning and also ended up being the cause of the first legal proceedings against me – the problem was we'd used the name 'CDU' without permission. (To date I've been involved in forty-one legal cases because of my posters; luckily I've won them all.)

After that came the poster *'Deutsche Arbeiter! Die SPD will euch eure Villen im Tessin wegnehmen'* ['German workers! The Social Democrats want to take your Ticino villas away'] – a complicated text for someone who can't think satirically. This was the big breakthrough: it's the most famous poster I've ever done, that Steidl and I did together. It had a print-run of 75,000 – unthinkable today – and we made 100,000 postcards and 100,000 stickers. Historically we were harking back to the 1920s, when poster art played a central role in politics: artists like George Grosz, John Heartfield and Käthe Kollwitz.

What was interesting was that our posters were never just ordered individually and hung by students on their bedroom walls, they were always displayed in public. The DGB [Confederation of German Trade Unions] in Baden-Württemberg for example, ordered five thousand *Deutsche Arbeiter* posters and hung them all – in the streets, on advertising columns, on sandwich boards – this is how they became well-known.

We also offered selections of posters like little exhibitions. People would buy them for twenty marks or so – we only ever sold things to cover the printing costs – and then rent a space and put on an exhibition. As a result we've had over three thousand exhibitions over the years.

[There is a pause in conversation and the sound of the industrial guillotine three floors below is heard: the great blade descending onto a stack of paper with a thud, the electric groan of the blade retracting.]

The great advantage of working with Steidl – and we both noticed this rather quickly – was that there was no third party involved, no one who could interfere.

MP: Were you already working with Joseph Beuys at this stage?

KS: Yes. I met Beuys in 1968, when I contacted him about a postcard of his I wanted for Documenta 4. There was a strong bond between us from the beginning that lasted eighteen years. It started as a friendship, but I ended up

printing his editions, over three hundred of them. I then introduced Steidl to him, who started printing most of his stuff. Steidl was also the one Beuys would call on whenever he needed an object made.

At one stage Beuys and I had a crisis of sorts for political reasons – he began supporting the Greens and I remained the stubborn old Social Democrat. We didn't speak for over a year, but during this time Steidl filled the vacuum perfectly, liaising between us so we could continue working together. Of course Beuys knew he was onto a good thing with us. That's something all artists value: someone who can realise their ideas in practical terms – be it making prints, casting bronze, whatever.

In 1974 we shared a wonderful experience: flying to America together. It was Beuys, Steidl, me, Caroline Tisdall and for some of the time the gallerist Lucio Amelio. We went to New York, Chicago, Minneapolis, and then back to New York. I think the only interview I ever did with Beuys was at JFK airport, and we got it all on tape – we'd bought the first Shibaden video camera and Steidl documented the whole trip. Beuys gave lectures in the different cities; the tour wasn't connected to an exhibition. His second visit to America was the famous one with the ambulance and the coyote, but I wasn't there for that. Then came the big Guggenheim show in 1979. *[Steidl returns to the dining room and resumes his place.]*

KS: Since then I've had permanent work. Steidl and I still have projects together, but I think it's a pity we don't work as closely as we did back then. Our collective roots lie in the early 1970s.

MP: Do you miss those times?

KS: I do. I remember how we'd drive our Volkswagen to book fairs and sell postcards and posters right from the back of the car. They'd chase us away but we'd just drive down the road and continue selling from there. They were wonderful times.

We used to put on big political events too – Steidl's a great organiser. We rented the Grugahalle in Essen twice and filled it with ten thousand people for five-hour events. The Mercatorhalle in Duisburg, the Westfalenhalle in Dortmund, the Siegerlandhalle in Siegen – all of them. I can't think how many events we put on.

GS: At least a hundred.

KS: At least. And we organised them by ourselves, we never had a partner.

GS: At election time we'd rent the halls and go on tour like a band, bringing together the biggest musicians, politicians and artists.

KS: Our goal was to create cultural-political events without the support of trade unions for example, to react against the kind of hypocrites who'll happily spend their money on a new Mercedes but aren't prepared to take a political stand on anything.

GS: You couldn't rely on the SPD back then either. In Nordrhein-Westfalen for example, they used to bring in entertainers from America and pay them 50,000 marks to perform – they called it 'Top Act' – but the contract always stipulated that they weren't allowed to do or say anything political. So the concerts would take place (the tickets were always cheap as the SPD had paid for it all) and were marketed as 'political' events, but in reality they were anything but.

Our idea was to mix it all up: to invite musicians from around the world who actually conveyed political content through their work and performance. And we'd always insist that there were speeches at our events.

KS: And all this at such risk: renting the Grugahalle cost 150,000 marks!

GS: We never had the money upfront. We were only ever able to pay because the events always sold out.

KS: We'd invite anybody from the Left who had a good name: Heinrich Böll, a central figure, came to one event.

GS: What I found so exciting about it all, and which you hardly see today, was the mix of young and old people. Fritz Eberhard for example used to come along, who joined the SPD in 1922 and helped rebuild a democratic broadcasting service in Germany after World War II. He also played a central role in securing the right to refuse military service in the new constitution of 1949.

KS: There was always such a wonderful atmosphere. Performers would appear for free, just because they believed in what we were doing. It was a time when people were simply happy to be involved – none of the speakers were ever paid, not even for the cost of their train tickets.

GS: [after a pause] Although I would say that similar times are returning, if you look at what's going on in America at the moment. (What's happening there will eventually reach Germany.) I heard Obama on the news this morning: 'America is no longer in a position to tell others how things should be done. Instead, we must establish dialogue with others.'

KS: I think German people tend to take more of a distance from a purely consumer society, which means they're not simply content to have money to spend but want to experience some deeper sense of well-being or satisfaction. The way things are now means people need to learn to take control of their own affairs again: they can no longer be passive observers. I think that's the perspective we need to adopt to maintain democracy. Our goal at *Aktion für mehr Demokratie* [Campaign for More Democracy] was always to show that democracy means *doing something* – not just sitting around and complaining about how things should be. Whenever Steidl and I weren't satisfied with an event we went to, then we'd simply try to put on a better one ourselves. It was the same when we didn't like something we printed. We never asked ourselves how much something was going to cost; instead, we'd say it was only allowed to cost ten marks, even when the printing costs were already over eleven.

GS: What was the name of that crackpot from the Bundeskriminalamt [Federal Criminal Police Office]?

KS: Horst Herold.

GS: Herold, yes! He was head of the Bundeskriminalamt, which is like the FBI in the US. He brought in the Rasterfahndung ['grid search'] in the late 1970s, a policy of surveillance by which computers were used to collect and analyse data from all over Germany supposedly to track down terrorists. This meant if you published anything – even if you were merely active in the field – then you came under the jurisdiction of the Rasterfahndung.

KS: They visited me twice to see if I was hiding terrorists.

GS: After a while we realised we had to confront Herold about this, to speak to him face-to-face. So we invited him to talk.

KS: Everyone was against the idea at first, but it ended up being our best-visited event. *[after a brief pause]* Of course we can't do any of this these days. One reason is a simple lack of time: Steidl's busy with his books and I've got my duties at the Akademie der Künste [Academy of the Arts] in Berlin.

GS: *[cheekily]* Perhaps you'll have more spare time when you're ninety?

KS: *[laughs]* Exactly. I'll be able to roll to Göttingen in my wheelchair.

GS: When I think about it, the method of working I learnt from Staeck is something I've been able to apply to all the artists I've worked with since. It's the same model. When we began working together, he used to give me a few

135

snippets from a newspaper or a sketch and say, 'Here you go, do what you want with it.' So I've always had room to play, and been able to decide for myself how to bring all the elements together in the final design. How old was I back then: eighteen, nineteen? When you're that young, all you want is to be an adult and conduct your affairs as you see fit, but there are always people – teachers, parents, family – who try and tell you what to do. With Staeck it was different: here was suddenly someone who trusted my judgement, despite my age.

KS: My experience with Beuys had been the same: he simply trusted me.

GS: I remember the first time Staeck told me to go and visit Beuys for myself to see how things got done. This working method is ideal: one person has the idea, the other expands it and then realises it to the best of his or her abilities. Curiously, faxing has played an important role for me from the beginning. Staeck and I had some of the first fax machines in Germany. They came out in 1972 and there were only four in the country: we had one each, Siemens (who invented the fax) had another, and the postal service had the fourth. I'm a devout faxer even today, and not through any sense of nostalgia. I simply believe it's the best way to transfer an idea from one's head onto paper and to communicate that to someone else. There's something unique in the handwriting of a fax.

KS: [after a moment's thought] Perhaps a way to sum up what we were trying to achieve back then would be to say we wanted to establish our own autonomous space within the public sector.

GS: To create a mini media company through which we could promote political independence and counterbalance the large money-driven corporations. To find one's own voice outside the ambit of the centralised government-influenced media. The *Bild* newspaper for example, has always been a favourite adversary of ours.

KS: Actually – and perhaps we can close on this – I've got an interesting story about the *Bild*. I've been invited to the opening of the exhibition *'Sechzig Jahre. Sechzig Werke'* ['Sixty Years. Sixty Works'] tomorrow in Berlin. It celebrates sixty years of the German republic and is quite a big deal: Angela Merkel's opening it. I'm showing work in it – and not just one piece, but twelve posters at the beginning of the exhibition – but when I got the invitation I saw I wasn't on the list of sixty artists. 'Oh, we're terribly sorry,' they said, 'we must have forgotten your name!'

136

They didn't forget me of course. They're intending to print work by each artist in the *Bild,* one each day for sixty days. And they know too well I would *never* agree for my work to be reproduced in that newspaper as it is now – an instrument of lies.

But they couldn't just print fifty-nine artworks, as everyone would wonder what happened to the sixtieth. So what they've done is to include the work of *another* artist, which leaves me as the sixty-first, so to say: I'm in the exhibition and catalogue, but not on the official list, and I won't be printed in the *Bild.* Which puts me in an interesting situation. One way to respond would be to take offence and withdraw my work from the exhibition altogether. But I won't do that. I'm going to make a poster about the hypocrisy of it all.

With these words, Staeck ends the interview, as if closing a book. Without hesitation, he and Steidl resume their work at the dining room table with the same conviction, verve and humour they have enjoyed for the past thirty-nine years.

David Bailey

'I've never been interested in photography. I'm interested in the image.'

London, 19 May 2009

'I don't smoke,' says David Bailey as he lights a cigarette and inhales. The curls of smoke rise, unravelling, from the tip of the cigarette, and Bailey laughs: a mischievous laugh that begins as a wheeze behind closed teeth before escaping his mouth with increased, high-pitched volume.

Bailey, seventy-one, stands in his inner-city London studio which occupies the upper storey of an eighteenth-century warehouse and has wooden floorboards, white-painted brick walls and iron girders running its length. He wears a denim shirt and baggy green-brown corduroy pants that slip down as he walks, despite being secured with a belt. His face is round, unshaven and kind. His moist brown eyes twinkle like those of a roguish adolescent.

One patch of wall in the studio is covered by Bailey's photos, including images of his wife Catherine, son Fenton, Kate Moss, and a self-portrait with Ronnie Wood. Next to these hangs a colour photocopy of Picasso's *Jacqueline in Turkish Costume* (1955). Nearby bookshelves house grey cardboard boxes with hand-written labels including 'Penelope Tree', 'Eye', and 'Young Mick'. In a corner of the studio sits a low coffee table on which lies today's issue of the London *Evening Standard,* with a photo of Paris Hilton and Peaches Geldof on the front page. On the wall above the table hangs a plaque with the text:

Nothing in the world can take the place of Persistence.
Talent will not; nothing is more common than unsuccessful men with talent.
Genius will not; unrewarded genius is almost a proverb.
Education will not; the world is full of educated derelicts.
Persistence and Determination alone are Omnipotent.

Steidl is visiting Bailey today before attending the launch at Home House of Bailey's *8 Minutes,* a book containing one hundred and thirty facial portraits of

Damien Hirst. This afternoon Steidl and Bailey have discussed an upcoming book of photos of Penelope Tree, which complements volumes already published on Jean Shrimpton and Anjelica Houston; a book of photos taken over forty years in London's East End where Bailey grew up; and a suite of books of recent photos taken in New Delhi, each to be bound in a different coloured cloth.

Before sitting down to be interviewed, Bailey begins talking of his own accord. His words are shaped by his relaxed, blunt manner and playful, often self-deprecating irony.

David Bailey: Actually I started a book in Australia, I was gonna call it 'Bailey's Matilda'. And I drove eight and a half thousand miles in Australia in the outback.

Monte Packham: Sunsets, you said?

David Bailey: Not sunsets no, I don't do sunsets.

Monte Packham: But something about the light.

David Bailey: Yeah the light. Charters Towers: I've seen skies like you've never seen. And there's no clouds in the sky so you wonder where it comes from – it must be dust from the desert that makes all the colours in the sky. Everyone there just ignores it because it happens every day.

[Bailey extinguishes his cigarette.] So what d'you wanna know? You have to ask me questions, you have to do some fuckin' work. *[laughs warmly]*

Monte Packham: When did you first meet Steidl?

David Bailey: I don't know. He's a myth isn't he?

MP: You think?

DB: Yeah. It's a preciseness. It's a very German thing, it's so precise, like Bach. They're so focused. He's probably one of the most focused men I've ever met. I don't know if it's good or bad – I mean I wouldn't want to live with him. But he understands photography.

Most publishers don't know the difference between a Leica lens and a Rollei lens; only Kubrick knew the difference and he's dead. You can't talk to most publishers about stuff like that, they wouldn't know what you were talking about.

MP: What was your first book, not with Steidl but overall?

DB: *Box of Pin-ups.* 1964. Twenty-five thousand pounds now.

MP: Really? You still have one?

DB: I've got two.

MP: And what is it about the photo-book that's important for you?

DB: 'Photo-book'?

MP: The photo-book: books of your photos.

DB: I've never been interested in photography. I'm interested in the image. I don't care how people make it – whether it's with a paintbrush or a camera, or with a stick like the Aborigines. It's not about photography, it's about … I hate art-speak but it's about 'something else'. Anyone can take a picture, especially now with those silly little digital things. It's what I said earlier, that everyone can take one great picture – but hopefully I'll do two. *[laughs]*

MP: Have you taken one already?

DB: Yeah, I'm up to two. But I've got a few more years left, God willing. I think photographers live a long while because God doesn't like them and doesn't want them in heaven. *[laughs]*

MP: What does a book allow you to do that an exhibition doesn't?

DB: Control things, and have somebody who's sympathetic to the way you see the book. Otherwise it'll just be another book. Anyone can do a book now. If you look at the market there's another art book every other day, and they're mostly crap. It's become an art thing in itself, the book. It's an object and everyone can afford it. Unless you wanna buy a *Box of Pin-ups,* then you've gotta start saving. *[laughs]* They had it on a TV programme the other day, one of my books – *The Apprentice,* you know *The Apprentice?* And they gave it to those stupid people.

MP: *Pin-ups?*

DB: No, no, they couldn't afford that, it'd cost more than the programme. It was another book, the *Stern* book. And one of the contestants said, 'Who's David Bailey? Is he foreign?' They had to go sell the book for as much as they could in this programme. One person sold it for twenty quid, and another bloke sold it for fifty. But if they were sensible they'd have just gone to Soho Books and gotten it for fifteen pounds anyway. *[laughs]* The whole thing's a bit of a nonsense. *[Bailey's assistant reminds him that the books on* The Apprentice *were in fact*

140

signed by him.] Oh, I signed them. Oh well then, fifty p more!

MP: Do you ever take photos with the idea of a book in mind?

DB: No. Books happen. They're never planned. Sometimes it's just a title, like 'Chasing Rainbows'. For that I thought about all these sad people who wanna look beautiful: they're all looking for something that's not there.

MP: Something that can't be reached.

DB: Yeah. So often the title becomes the book. I did a book once *Black and White Memories*, which is so badly printed. I saw it the other day because I took it to India, because I wanted some guys to copy it. You forget how much printing's improved in the last twenty years really. When I used to shoot for *Vogue* – well I still shoot for *Vogue*, now their printing's beautiful – but before, you'd have a red river in your photo and they'd change it into a blue river. There was no control on colour like there is now.

MP: And you had no control either?

DB: Nobody had any control. When I first started, you could only use plate cameras at *Vogue*. I got away with thirty-five millimetre because I used to put them in the enlarger and blow them up. And I'd show them the contacts, so they thought I was using a bigger camera. This went on for eighteen months before they discovered I was using thirty-five millimetre. But by then they'd already published so it was all right. Now they don't ask, they just get my choice. In the early days it was a real struggle. But all this isn't about Steidl... How many publishers in the world can you go to and say, 'I wanna do a book in eight minutes,' and he gets it? There's not many people like that.

MP: Why is he like that?

DB: I dunno, something in his genes. I dunno, it's that preciseness that Germans have.

MP: Is it frustrating sometimes?

DB: No, it's good. Why would it be frustrating?

MP: Not Gerhard's precision, but working with him?

DB: Sometimes it's difficult to find where he is, that can be frustrating. *[laughs]*

MP: But when he's here, it's all right?

DB: *[looking over at Steidl who is seated before the coffee table]* Yeah. Well I'm quite precise too so I think we get on well together. I think. You'd have to ask him. He looks very smart today in his poncy suit and tie.

MP: Last question – and not Steidl-related – did you really steal Diana Vreeland's door knocker?

DB: Tried to.

MP: It didn't come off?

DB: No, it's in her autobiography. Jack [Nicholson] and I tried to unscrew it. It was four o'clock in the morning. And she was tearful in the back of the car. And there's Jack and I trying to steal the door knocker, one of those lion door knockers. Luckily the police didn't come. *[laughs]*

MP: And she was tearful because you couldn't get it?

DB: No, she was just remembering when she lived in London before the war, probably in the thirties. She was half British, Vreeland. But you never knew with Vreeland because it was always fantasy.

An hour later, shortly before departing for Home House, Bailey places a cigarette in his mouth and reaches for a box of matches. He strikes a match and Steidl pounces – the cigarette is the wrong way round, the filter dangles from his lips. Bailey rotates the cigarette, lights it, and laughs as he inhales. The curls of smoke and laughter disperse into the air.

Dayanita Singh

'I want something ordinary on the outside and like a jewel inside.'

New Delhi, 20 September 2009

Dayanita Singh's *Sent a Letter* is a linen-covered cardboard box containing seven little books of black-and-white photographs. The linen is thin, coarse, and of a dull cream colour that accumulates dirt. The linen has been crudely cut and glued to the inside and outside of the box; the fabric's fraying edges are visible in places. The box sits comfortably in one's hand. This is a complete but unfinished, humble, and welcoming object.

One opens the box by taking it in two hands and 'unfolding' it – there is no separate lid. Doing so reveals a hollow in which the seven books nestle. The books are nine centimetres wide and thirteen and a half centimetres high, bound in flexible cardboard, and stand vertically in their box as if on a miniature library shelf. Six books are fawn-coloured; the seventh is olive-brown. The spine of each fawn book bears one of six Indian place names written vertically in black Helvetica capitals: 'Allahabad', 'Bombay', 'Calcutta', 'Devigarh', 'Padmanabhapuram', and 'Varanasi'. The woman's name 'Nony Singh' adorns the spine of the olive-brown book.

Between the covers of each book is a long strip of paper folded into concertina form. Photographs, mostly square in format, occupy one side of the strip, so that when unfolded it can be stood on a horizontal surface and its photographs 'read' (from left to right?). The images depict a spectrum of environments across India: private and public, natural and urban, impoverished and lavish, with and without people. Individual compositions include shelves laden with white crockery, a herd of goats walking down a street past parked cars, a crowded market place, dark ocean waves breaking against rocks, a fluorescent lamp on a bedside table, and empty corridors.

Printed in black across the four sides of the box – one must turn the box in one's hands to read the text – are the words: 'Sent a letter to my friend, on the way he dropped it. Someone came and picked it up and put it in his pocket.'

143

Monte Packham: How did *Sent a Letter* become what it became?

Dayanita Singh: The story began in 2006 when Gerhard came to Calcutta with Günter Grass. We spent a few days there, perhaps three, just wandering. Gerhard had wanted to see some of the paper- and book-making parts of the city, so I found some places and on our long walks together I took pictures – as I often do when travelling with friends. These were just photographs of things we passed, perhaps things Gerhard pointed to – once he went and talked to a goat and I took a picture of it – all very casual. When I came back to New Delhi I did what I've been doing for many years which is to put all the photographs into a black Moleskine, connected together as a remembrance of a time shared with someone, and as a way to say thank you. I made two books: kept one for myself and sent one to Gerhard. Of course there was no response from him. *[laughs]* A little while later Gerhard was in London and I was there too, staying at the Frith Street Gallery apartment. I took him upstairs to show him my copy of his book and he said, 'We should do something with this.'

'No no no,' I said, 'this is my own little project: it's too private, it was only meant for you.'

'No no no, we'll definitely do something with it.'

'But what should I do?' I said. 'I have all these books – I must have five on Calcutta alone, each about a different journey with a different friend.'

'Don't touch them. Don't try to make a "Calcutta" volume,' he replied. 'We're going to print these books exactly as you made them.' And that's what we did. I think it was in 2007 when we made *Go Away Closer* that I said to Gerhard I would like the book to be ordinary on the outside and like a jewel inside. So when it came to *Sent a Letter,* I said I would like a jewel box for these seven books – but on the outside very simple. When I got back home I started working on the box using the fabric we use for posting parcels in India: in the end three thousand boxes were shipped from New Delhi to Göttingen!

MP: How did the concertina form of the books take shape?

DS: When I began making these books in 2002, I was lucky enough to go on a number of journeys with some incredible minds, writers and thinkers, and I thought: 'What can I give them? I can't just give them one little

print.' So I started making these books and discovered the Japanese Moleskine with the concertina form. I made one for my friend Fausto when I visited his house in Florence. He then took the book to Greece and left it at someone's house by mistake. Another friend took his book to Washington and put it in his office. So over time the books spread and began to form a secret exhibition taking place in different parts of the world. The concertina structure is also important because each strip of images is composed like a piece of writing. And there are hidden codes in them – in the Calcutta book for instance, there are things that only Gerhard and I would know the significance of.

MP: For whom was one of the other books in *Sent a Letter* made?

DS: I made the Allahabad book for Sunil Khilnani who wrote *The Idea of India*. He was in Allahabad doing research for his biography on Nehru and I went with him. While he was working I did what I know how to do which is to take pictures, but I kept thinking to myself, 'Sunil would like to see this,' and 'Sunil would like a record of that.' So after I came home I made a book for him and one for myself. Similarly the Devigarh book is about a trip I took with him to Devigarh. Often the person I'm with is standing right next to me when I take a picture – I might be the one pressing the shutter, but the image is actually a conversation that takes place between that friend and myself about the very thing I'm photographing.

MP: And the seventh book 'Nony Singh' named after your mother?

DS: That's a book I made for my mother of her photographs. She's always made albums of everything – she even has an album of my father's girlfriends. So I thought it would be nice to make her my version of one of her albums. We gave the book a different coloured cover to distinguish it from the others, although I never wanted it to be clear that these are my mother's pictures and that I'm often the one photographed. Some who see the book realise these are her photographs, and others don't – an Australian friend of mine thought they were self-portraits of me pretending to be someone else. And Gerhard is a great accomplice in these kinds of secrets that will never be resolved; they've become a big part of our book-making.

MP: *Sent a Letter* has been exhibited in a variety of environments, most charmingly in a jewellery store – how did that happen?

DS: In 2008 I showed *Sent a Letter* in a gallery in Calcutta where I had an exhibition

of the ladies of Calcutta, of all the women I've ever photographed there. We'd made little shelves for the books but they were getting lost and somehow I wanted other audiences for *Sent a Letter* – now that I had this mass-produced object and not a limited edition, I didn't quite see the point in only showing it in an awe-inspiring gallery environment.

I had the box in my hand and had gone out for coffee behind the gallery when I walked past this beautiful jewellery store [Satramdas Dhalamal] with empty vitrines in the windows. 'This is it!' I thought. 'It's just waiting for my books.' So I went in and introduced myself to the owner, Raj Mahtani, who luckily knew and admired my work.

'Fantastic,' I said. 'Perhaps then there's something you could do for me?'

'Sure.'

'How about giving me your windows?'

'Please do whatever you like,' came the reply.

And the books are still there! Gathering dust. Raj makes big jewels, so he can't put them in the window. Outside the jewellery store is a little *paan* shop and its owner has become the guide to the exhibition and tells people which place each book depicts, as you can't see the names on the spines when you stretch out the books. In the end, all the discussions I'd ever had with Gerhard about whether a book can be the art object in itself realised themselves in *Sent a Letter*.

Once the paper concertina of each book in *Sent a Letter* has been folded together, the seven books returned to their box, and the box closed, one is left with a quiet object whose unassuming exterior belies the photographs held within it. Yet while this object is quiet, it is not silent: 'Sent a letter to my friend, on the way he dropped it. Someone came and picked it up and put it in his pocket.' These words not only colour one's appreciation of Singh's photographs, but suggest that *Sent a Letter* is something to be passed on – that it is indeed intended for someone else. Here lies its contradictory charm: the impulse to give away a jewel-like object one does not want to part with.

Conclusion

22 October 2009

6:31 pm

The steel door closes with a soft thud as one passes from the typography level back into the internal stairwell of Düstere Strasse 4. Open cardboard boxes containing books, catalogues and envelopes occupy the landing. A light bulb in a metal ceiling fitting casts a cool gleam onto the bright colours of the printed materials in the boxes. The pale terrazzo staircase winds downwards.

At the bottom of the stairwell, where hundreds of printing plates lean against the walls, the muffled din of the Roland 700 is audible: the press is idling, waiting for a fresh pallet of paper to be loaded into it. Walking through the pressroom, one returns to the terracotta-tiled entrance hall where a wooden door faces Düstere Strasse. Turning the handle, the door swings open into the cool air of the street.

It is raining this autumn evening. The red bricks of Düstere Strasse glisten. The dusk sky is deep blue, edging towards black but still luminous. People pass by: two laughing teenage girls, an old woman shuffling under an umbrella, a man in a raincoat pushing his bicycle. A small open window on the façade of Düstere Strasse 4 allows the rhythmic beating of the Roland 700 to escape onto the street – paper has begun moving through the press again.

Gradually, the rain subsides to a sprinkling. Opposite the window a shallow puddle has formed. As each raindrop hits the surface of the puddle, circular ripples radiate from the point of impact. The circles race towards the edges of the water surface as they are disturbed by newly fallen drops. And people continue to pass by Düstere Strasse 4, unaware of the circles around them.

Coda

15 October 2010

10:16 am

Almost a year has passed since I wrote the conclusion to *Concentric Circles*. During this time, life and work at Düstere Strasse 4 have continued much as described within these pages. While the projects and some characters may have changed, the bustle of book-making remains unabated. The publication of *Concentric Circles* has been unexpectedly delayed, but now the book is ripe for printing (says Gerhard with a wink). It is to be bound in cloth and have a red bookmark, a scarlet flourish between pages of black and white.

<div align="right">M.P.</div>

Biographies

Born in London in 1938, **David Bailey** worked as a photographic assistant for John French in 1959. Bailey's photography first appeared in *Vogue* in 1960, and he has since published extensively. A definitive photographer of his generation, Bailey was awarded an Honorary Fellowship by the Royal Photographic Society in 1979, and a CBE in 2001.

Born in 1945 in Newport Beach, California, **Lewis Baltz** studied at the San Francisco Art Institute and Claremont Graduate School. Baltz is associated with the New Topographics movement of the 1970s, and his awards include a Guggenheim Fellowship and the Charles Brett Memorial Award. Baltz's work is held in many public collections.

Born in 1947 in Paris, **François-Marie Banier** is a novelist, playwright and photographer. Banier's novels include *Les Résidences secondaires* (1969) and *Balthazar, fils de famille* (1985). His visual work has been shown at the Centre Pompidou and the Maison Européene de la Photographie in Paris among other institutions.

Tacita Dean was born in 1965 in Canterbury and studied at the Falmouth School of Art and the Slade School of Fine Art, London. Dean's favoured media include drawing, photography and film, and her solo exhibitions include those at Tate Britain and the Musée d'Art Moderne de la Ville de Paris.

Born in 1935 in Cincinnati, Ohio, **Jim Dine** completed a Bachelor of Fine Arts at the University of Ohio in 1957. Dine is a prolific painter, print-maker and photographer, and drawing is central to his eclectic practice. Initially associated with the Pop movement, Dine's career spans over forty years and his work is held in numerous private and public collections.

William Eggleston was born in 1939 in Memphis, where he still lives and works. Eggleston's photographs were the subject of the first solo exhibition of colour photography at the Museum of Modern Art, New York, in 1976. He is acknowledged as a major influence in the recognition of colour photography as art.

Born in 1971 in Copenhagen, **Joakim Eskildsen** trained with the Danish court photographer Rigmor Mydtskov, before moving to Finland in 1994 to learn book-making at the University of Art and Design in Helsinki. Eskildsen's book awards include a gold Deutscher Fotobuchpreis and the Otto Pankok Prize.

Robert Frank was born in Zurich in 1925 and immigrated to the United States in 1947. Best known for his seminal book *The Americans* (1958) and the film *Pull My Daisy* (1959), Frank has been a key influence on the still and moving image over the past fifty years. Major exhibitions of his work include those at Tate Modern and the National Gallery of Art, Washington, DC.

Born in 1927 in Danzig, now Gdańsk, Poland, **Günter Grass** studied sculpture and graphic art in Düsseldorf. His first volume of poetry *Die Vorzüge der Windhühner* was published in 1956, and his debut novel *The Tin Drum* in 1959. A major figure in postwar German literature, Grass received the Nobel Prize in Literature in 1999.

Writer and stylist **Amanda Harlech** was born in 1959 in London. After studying English literature at the University of Oxford, Harlech became a fashion editor at *Harpers & Queen*. She subsequently worked with John Galliano for twelve years and today is a consultant for Karl Lagerfeld.

Born in New York in 1955, **Roni Horn** lives and works in New York and Reykjavik. Horn employs multiple media in her art including drawing, photography, sculpture and book-making. Her solo exhibitions include those at Tate Modern, the Whitney Museum of American Art, and the Fotomuseum Winterthur.

Born in Hamburg in 1938, **Karl Lagerfeld** is a fashion designer, photographer, publisher and bookseller. Lagerfeld's awards include the Lucky Strike Designer Award from the Raymond Loewy Foundation, the cultural prize from the German Photographic Association and the Trustees' Award from the International Center of Photography in New York.

Sculptor and painter **June Leaf** was born in 1929 in Chicago, where she studied at the New Bauhaus and Roosevelt University. Leaf held her first solo exhibition at Sam Bordelon Gallery in 1948 and has since exhibited internationally.

Born in Boston in 1940, **Diana Michener** holds a Bachelor of Arts from Barnard College in New York and later studied with Lisette Model at New York's New School. Michener has exhibited internationally, including a retrospective at the Maison Européene de la Photographie in Paris in 2001.

Robert Polidori was born in 1951 in Montreal, and lives and works in New York. Polidori holds a Master of Arts from the State University of New York, has worked as a staff photographer for *The New Yorker*, and his accolades include two Alfred Eisenstaedt Awards for Magazine Photography and a World Press Award.

Born in 1937 in Omaha, Nebraska, **Ed Ruscha** moved to Los Angeles in 1956 to attend the Chouinard Art Institute. Ruscha held his first solo exhibition at the Ferus Gallery in 1963 and has since worked prolifically as a painter, print-maker, photographer and book-maker. His work has been the subject of numerous museum retrospectives.

Born in 1965 in New York, **Fazal Sheikh** holds a Bachelor of Arts from Princeton University. Sheikh often depicts displaced communities in developing countries in his work, and his awards include the Leica Medal of Excellence and the Prix d'Arles. He has exhibited at institutions such as Tate Modern and the Fondation Henri Cartier-Bresson in Paris.

Dayanita Singh was born in New Delhi in 1961 and studied at the National Institute of Design in Ahmedabad and at the International Center of Photography in New York. Singh has exhibited at institutions including the Serpentine Gallery, London, and Hamburger Bahnhof, Berlin. Handcrafting books is central to her practice.

Born in 1938 in Pulsnitz near Dresden, **Klaus Staeck** is one of Germany's most prominent graphic artists. Renowned for his political posters, Staeck has been president of the Akademie der Künste in Berlin since 2006.

Printer and publisher **Gerhard Steidl** was born in 1950 in Göttingen, Germany, where he still lives and works. He received his informal printing training from Klaus Staeck and Joseph Beuys, and in 1972 the first Steidl book *Befragung der Documenta* was published. Since the mid-1980s Steidl has published literature including the work of Nobel laureates Günter Grass and Halldór Laxness. In 1996 Steidl founded an international photo-book programme.

Born in New York in 1944, **Joel Sternfeld** holds a Bachelor of Arts from Dartmouth College, New Hampshire. Sternfeld's awards include two Guggenheim Fellowships and the Prix de Rome. Sternfeld's first book *American Prospects* (1987) is an ironic, tender look at American life; his recent work explores the effects of climate change.

Born in 1964 in Erlangen, Germany, **Juergen Teller** has lived in London since 1986. His fashion photography has been published extensively, and solo exhibitions of his work have been held at the Fondation Cartier pour l'art contemporain, Paris, and the Kunsthalle Wien among other institutions.

Monte Packham is a writer and editor living in Germany. Born in 1981 in Sydney, he has bachelor degrees with honours in art history and law from the University of Sydney. Packham's writing has been published in *Art & Australia, sleek* and *Another Magazine* among others. Since 2007 he has worked as an editor at Steidl.

First edition published in 2010

Cover art: Jim Dine
Book design: Steidl Design
Scans: Steidl's digital darkroom
Production and printing: Steidl, Göttingen

Steidl
Düstere Str. 4 / 37073 Göttingen, Germany
Phone +49 551-49 60 60 / Fax +49 551-49 60 649
mail@steidl.de
www.steidlville.com / www.steidl.de

ISBN 978-3-86930-024-5
Printed in Germany